IMAGES
of America

MANITOU SPRINGS

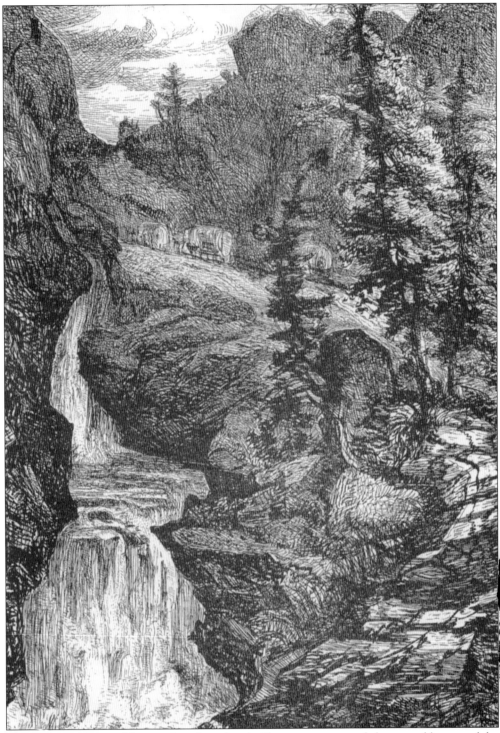

Eliza Greatorex, one of America's earliest female illustrators, captured the rugged beauty of the Ute Pass Road just west of Manitou Springs in her 1873 book *Summer Etchings in Colorado*. (Courtesy Historic Manitou, Inc.)

IMAGES
of America

MANITOU SPRINGS

Deborah Harrison

ARCADIA
PUBLISHING

Published by Arcadia Publishing
Charleston SC, Chicago IL, Portsmouth NH, San Francisco CA

Printed in the United States of America

Library of Congress Catalog Card Number: 2003109956

For all general information contact Arcadia Publishing at:
Telephone 843-853-2070
Fax 843-853-0044
E-mail sales@arcadiapublishing.com
For customer service and orders:
Toll-Free 1-888-313-2665

Visit us on the Internet at www.arcadiapublishing.com

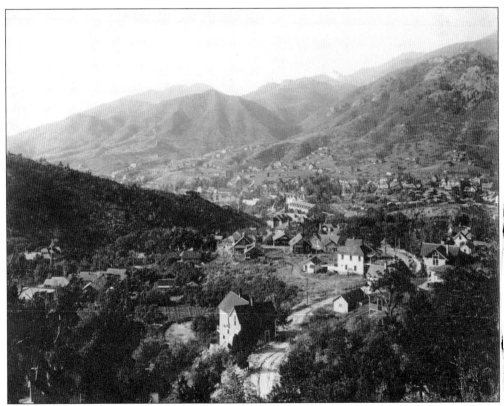

Many homes, boarding houses, and rental cottages were perched atop Agate Hill, at the mouth of Williams Cañon, for the spectacular views of Manitou and the surrounding foothills. (Courtesy Historic Manitou, Inc.)

CONTENTS

ACKNOWLEDGMENTS

As with most books, I'm just the focal point of the efforts of many others for which I would like to express my gratitude. Thanks to Jan McKell for giving me the idea to write this; my family and special friends for their steadfast support of my delusions of literacy; ever patient Leah and Kelly from the Colorado Springs Pioneers Museum; Theresa Blair, Manitou fiction writer extraordinaire, for her editing expertise; Jean Garrity, Edwina Forde, Diane Coates, Betty Jo Cardona, Dick Goudie, Carol Davis Warner, Ed and Meg Nichols, the Manitou Springs Volunteer Fire Department, the Manitou Springs Community Congregational Church, the Manitou Springs Public Library and Historic Manitou Springs, Inc. for contributing their rare and amazing photographs. Finally, my most humble thanks to Ed and Nancy Bathke for letting me run my fingers through their fantastic collection and trusting me with some of their amazing images.

INTRODUCTION

"Unique" is the best word to describe Manitou Springs, a small town on the outskirts of Colorado Springs that remains a world apart. Geography played a role in that separation by creating a natural backdrop of narrow valleys, enveloping foothills, and the ever present focal point of Pikes Peak set against the broad, rolling vistas of the Great Plains. Drama was provided by the effervescent springs, whose hissing, bubbling song has attracted every visitor since the native tribes first passed through following game to the summer hunting grounds.

Those original travelers knew there was something special about the cold, mineral laden waters that soothed stomachs and softened skin, which they attributed to some healing spirit that lived and breathed there. They passed on their knowledge, first to the Spanish colonials and then to roaming French trappers, who named the little creek flowing through the valley Fontaine qui Bouille, or "Boiling Fountain." Next to arrive were the American explorers, sent on missions to identify and document anything of interest. They did their jobs well, and more visitors stopped to taste the now famous springs on their way west.

John Charles Fremont, known as the Pathfinder, explored the area in 1842 with Kit Carson as his scout and wrote about his discoveries in a popular book. George Frederick Ruxton, a restless British officer who took great pains to find the "boiling springs," wrote a well read account of his journeys. Soon after, hordes of miners were passing by the tempting waters, stopping to rest before heading to the goldfields in Central City or Black Hawk.

Finally two men came to drink and decided to stay. Gen. William Jackson Palmer and Dr. William Abraham Bell had just met on a railroad survey, but could already see the signs of a meaningful partnership. They had a vision of dreamy summer villas nestled in the mountains, with grand hotels and landscaped parks clustered around the springs. To clear their heads they stripped and swam in the roiling waters, but the revelation remained and so did they.

Palmer and Bell's first hurdle was the formation of the Denver & Rio Grande Railroad that was supposed to link Denver with all parts of Colorado, including their new development, and ultimately with Mexico. Next the Colorado Springs Company was created to buy this valley of the mineral springs and the adjoining plains to the east. Stakes were laid around the railhead, where the urban center would grow. This area, now the city of Colorado Springs, was named

Fountain Colony, while the jewel of the development became La Font. An influential investor, William Blackmore, thought the new names had no mystique, but he felt that "Manitou," the great spirit of the eastern Algonquin tribes, so often mentioned in Longfellow's *Song of Hiawatha*, would be perfect.

Just as the little town began to take shape, a depression spread across the country in 1873, threatening to destroy any dreams of success in far flung Colorado. Those large villa lots for the moneyed classes were broken down into homesteading plots and landscaped grounds became storefronts. Although Palmer and Bell would never see their vision of a perfect place made reality, the result was a bustling, pleasant resort with bright aspirations for the future.

Manitou came into its own as the first and best tourist destination in a state filled with natural wonders. For many Victorians, the craggy peaks and bottomless gorges of the Continental Divide were too big to comprehend, but the softer scenery of Pikes Peak could be understood and admired. Health seekers came by the thousands, along with tourists just wanting to see the fabled west from the front veranda of a comfortable hotel. The town grew and prospered until it reached a golden zenith just at the turn of the century. The heyday couldn't last and it didn't, but the slide from health resort to vacation wonderland created its own blend of antique kitsch with a dash of charm. The Manitou Springs of today echoes with remnants of the past and has truly achieved a unique status among other Colorado towns.

One

BEGINNINGS
THE 1870S AND 1880S

According to Native American tradition, the many tribes in the area considered the valley of the mineral springs to be sacred. This photograph, documenting a lone encampment, was taken between 1874 and 1879, when the Utes made occasional visits to their former hunting grounds. (Courtesy Historic Manitou, Inc.)

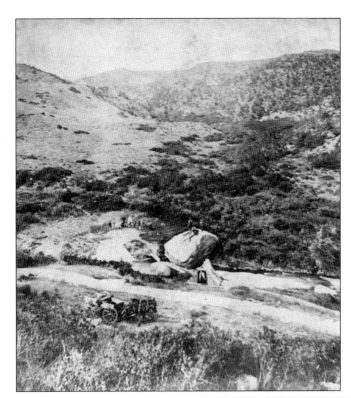

Once the area around the mineral springs was partitioned for sale by the federal government many men owned them before Palmer's Colorado Springs Company. One such land holder may be seen here, standing in his tent next to the Navajo spring. The Manitou Soda spring is across the stream, now known as Fountain Creek, to the left of the signature boulder.

This view of the Navajo Spring shows the natural accretions that built up at the creek's bank over thousands of years. That such proper gentlemen as General Palmer and Dr. Bell would go skinny dipping in the effervescent water is a testament to its special qualities. Bell remembered the incident many years later, reporting that their skin turned the color of lobsters. (Courtesy Ed and Meg Nichols.)

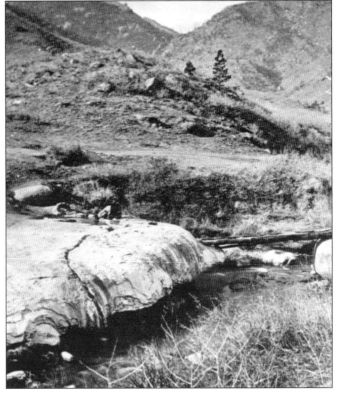

10

This intimate view of General Palmer was taken by his daughter, which may account for his hint of a patient smile. The General and his partner Dr. Bell understood the symbiotic relationship between their new railroad and Manitou Springs. The train transported wealthy investors from the East and Europe to their attractive resort town of Manitou, where they would be tempted to settle permanently. (Courtesy Colorado Springs Pioneers Museum.)

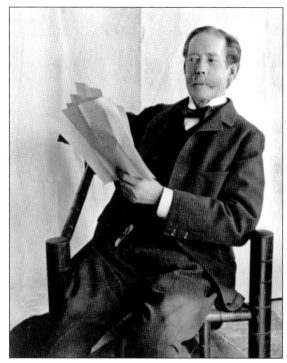

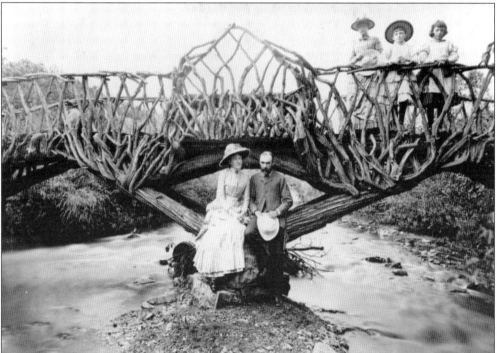

Dr. William Bell, seen here with his wife and daughters on the bridge at their estate, is considered the founder of Manitou Springs, not because he contributed more financially than General Palmer, but because he settled here, setting a genteel tone for the development of the new town. (Courtesy Colorado Springs Pioneers Museum.)

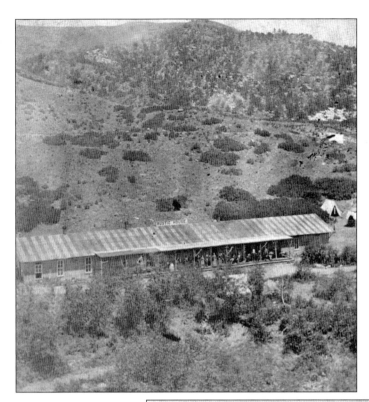

The first permanent structure in Manitou Springs, although that description may have been debatable, was the Rustic Inn or Temporary Inn, built by Palmer to house his family and friends during the winter of 1871. After moving into Glen Eyrie in 1872, Palmer sold the "Inn," which was eventually torn down at the end of 1875. This view shows an expanded version of what the General built, located in what is now Soda Springs Park.

By the spring of 1872, the Colorado Springs Company hired Canadian landscaper John Blair to lay out the future resort of Manitou Springs. He erected a rustic pavilion by the Manitou Soda Spring, built in the fashionable resort style of the day, and connected it to future hotel and villa sites with landscaped walkways and bridges. (Courtesy Historic Manitou, Inc.)

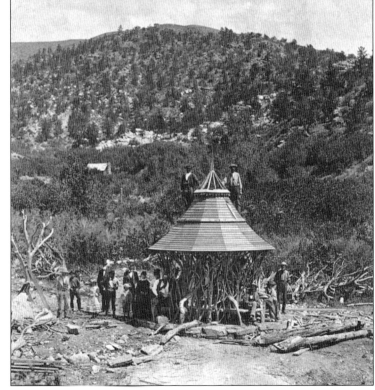

The Manitou House, the first "grand" hotel, opened for business in August of 1872. Occupancy rates often exceeded capacity in the early years and the on-site laundry, kitchens, and private reservoir barely kept up with demand. The long double porches were famous for peaceful evening strolls. Located near the present day Seven-Minute Spring, the beautifully landscaped grounds eventually became Memorial Park. (Courtesy Historic Manitou, Inc.)

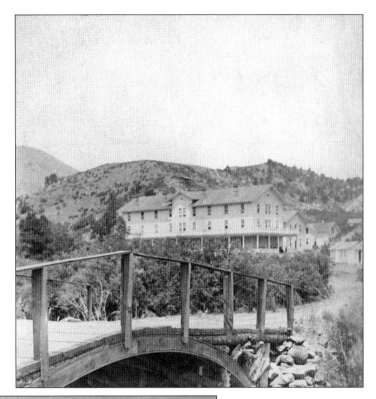

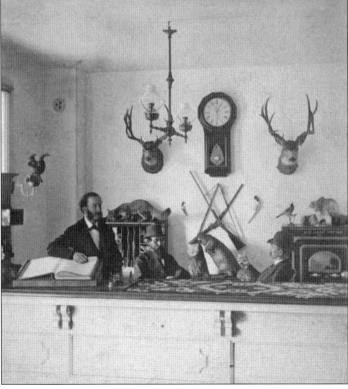

Based on this view of the Manitou House lobby, East Coast hotels had nothing to worry about. However, by the standards of the Wild West, elegance abounded. For the convenience of guests, every form of wildlife available for shooting was on display. For most of Manitou's history, the hotel manager was also a migratory species. The one exhibited by the register book is believed to be William Iles, an Englishmen who once taught cricket to the royal princes. (Courtesy Historic Manitou, Inc.)

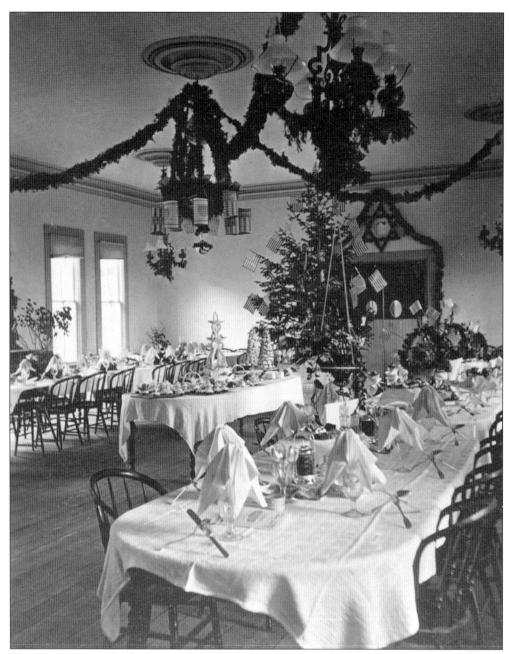

This picture captures the homespun elegance of the spacious Manitou House Dining Room, decorated for a patriotic event. Advertisements of the day boasted that 120 people could be seated there at one time and ladies could enter from the upper floors by a special staircase located out of view from the lobby. The Manitou House was initially open year-round and this large room provided ample space for early social gatherings, especially in the winter season. Literary figures would give public readings and guests would put on their own theatrical productions. The most popular events were the dances called "hops," where guests and locals could get together to waltz the night away. Newspaper articles decried the number of buggy accidents that occurred after such events.

Living in tents wasn't only for those who couldn't afford the rather extravagant rates of the hotels. Tuberculosis sufferers flocked to Manitou Springs to take the cure, and the best remedy of the day was to absorb as much fresh air and mineral water as possible. These tenters in Englemann Cañon have brought their own portable pantry with them. The famous springs were only a short walk away. (Courtesy Historic Manitou, Inc.)

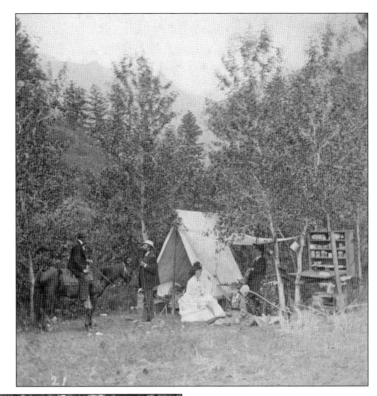

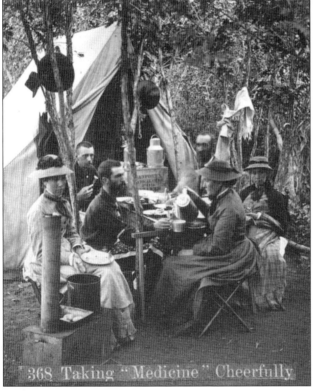

368 Taking "Medicine" Cheerfully

Overcrowded conditions in the large cities, combined with bad food, bad water, and pollution created an epidemic of Tuberculosis in the Victorian era. Whole families could become victims of the contagion, as might be the case in this view. The dry, high altitude climate of Manitou Springs might have had as much to do with recovery rates as the famous water, but hope was the most valuable commodity.

15

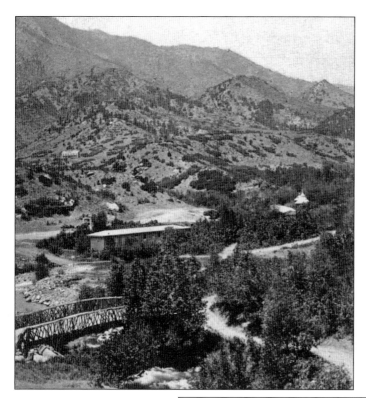

The fledgling health resort's first step towards spa status was a bath house. The long shed by Fountain Creek was Manitou Springs' initial attempt. Newspaper articles never revealed the source of water, but the location suggests the Navajo, Shoshone, or Mishatunga—a spring that disappeared in the 1870s after a flood. The distant building in the hills is the Iron Springs Hotel. (Courtesy Historic Manitou, Inc.)

The Iron Springs Hotel, owned and operated by Dr. Strickler, was more of a boarding house than a grand hostelry. The doctor became notorious in the local papers for charging the public to drink from his Ute Iron Spring, which was a short walk up the valley from his hotel. Two more structures would carry the same name after this building burned in the early 1880s.

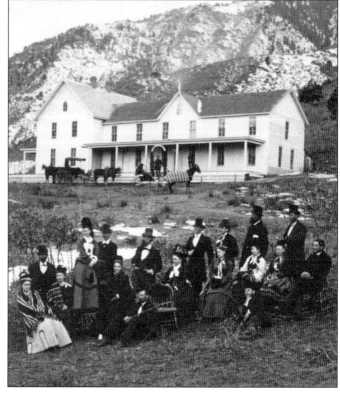

The Cliff House was Manitou Springs' second large hotel, funded by two Canadian entrepreneurs named Shurtleff and Webster. The first notice of construction was in January 1874, and the grand opening was celebrated in early June. This image illustrates the Cliff House's most important asset: its proximity to the Manitou Soda and Navajo Springs. (Courtesy Historic Manitou, Inc.)

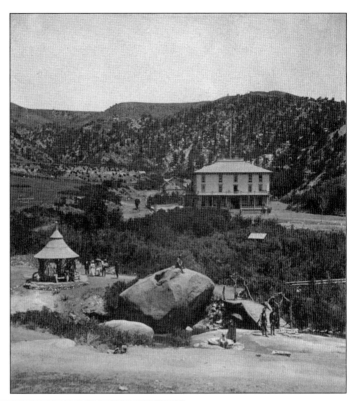

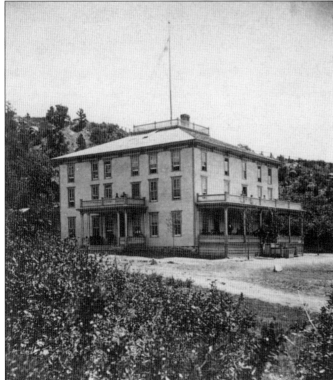

The Cliff House catered to a slightly less affluent clientele than the Manitou House and had less capital backing it. It still managed to accommodate a hundred people within its boxy walls, almost as many as its larger competitor. This photograph dates from 1874, before an addition was constructed.

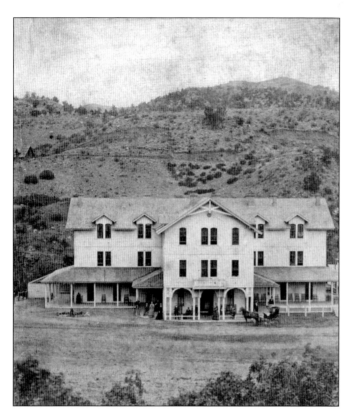

The Mansions Hotel was also built in 1874 to help alleviate the overcrowded conditions of the summer months. Another Colorado Springs Company project, it was never intended to stay open year round or serve meals. An enterprising businessman named Numa Vidal soon built a restaurant next door, called the Maison Doree. It was soon to be incorporated into the Mansions. (Courtesy Historic Manitou, Inc.)

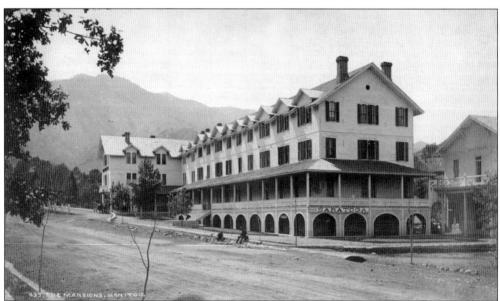

By 1875 Dr. Bell decided to renovate the Mansions into one of the best hotels west of the Mississippi. Twenty thousand dollars was spent on the extensive additions and luxurious furnishings. The sign at the end of the veranda reads "Saratoga Hall," which was Manitou Springs' first official hall for public gatherings. To the left is a log-covered cottage, built for the hotel and named after Helen Hunt, the author.

This quaint cottage on Manitou Avenue was built by an artist named Theodore Pine, *c.* 1872. Both he and his father were invalids, so their prime location on the main commercial street directly across from the Shoshone Spring was ideal. The Pines probably took in boarders as well, which was common for most Manitou Springs homeowners in the summer.

Mr. Charles Barker, a former schoolteacher and manager of the Manitou House, decided to buy Pine Cottage in 1881 and expand it into a first-class guesthouse named after himself. This view shows the first of many additions. The hotel buggy, used to convey guests from the railway station, stands in front followed by the transfer wagon, meant for luggage hauling in an age when guests stayed for months. (Courtesy Historic Manitou, Inc.)

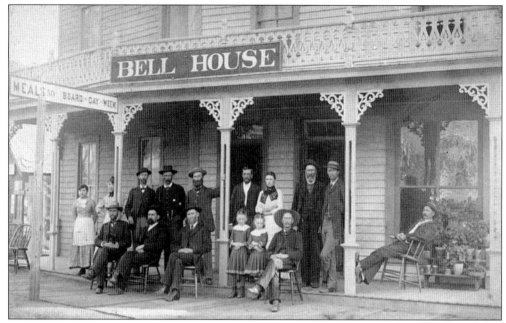

The Bell House was one of Manitou Springs' more reasonably priced downtown hotels, where a room would cost you two dollars on the American plan, which included meals, rather than four dollars at the Mansions. In this view, Mr. Bell sits on the front porch with his wife, daughters, staff, and guests. Ownership seemed to change with the seasons in Manitou Springs and this building would be known by many names over the years, including the Avenue Hotel.

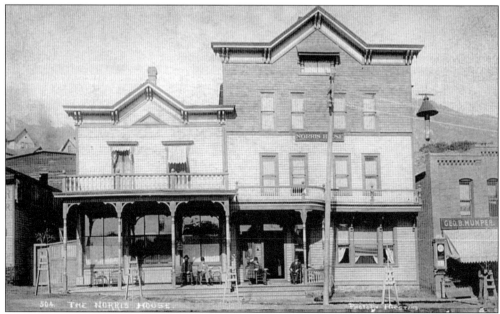

Manitou Springs attracted a large number of female entrepreneurs. Most ran boarding houses, though there were Anna Chamberlain, a dentist, and Dr. Harriet Leonard at the bath house. Mrs. Norris ran the successful Norris House Hotel, seen here after a major enlargement, and was well known for her generous hospitality.

This early view of the Sunnyside Hotel, run by the genial Captain Rogers, shows the middle stage of the evolution of a typical Manitou Springs hostelry. The owner would start with a small cottage, adding on as business improved, until the final product was a quite substantial hotel. The Sunnyside was located just off Pawnee Avenue, behind the Congregational Church. (Courtesy Historic Manitou, Inc.)

The taking of this picture of the Ohio House, a boarding house on Ruxton Avenue, was obviously a special occasion for the guests and staff who are posed artfully around the building. Even the cook can be seen near the kitchen door on the far left. During the busy summer season, tents, like those on the left, were erected in every available space. Mrs. Galbreaith, the owner, was also the image-maker, and ran a successful photographic studio near the Barker House. (Courtesy Historic Manitou, Inc.)

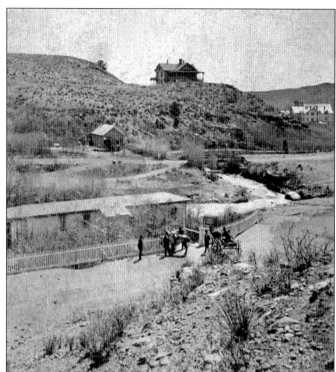

Lord Cecil Standish, a citizen of Great Britain, decided to erect the large summer residence, seen at the top of this picture, in 1874. The land was originally owned by the Mellen family, in-laws to General Palmer, who soon repurchased the property. The grand home had a panoramic view and remained the most prestigious rental address in Manitou Springs. (Courtesy Historic Manitou, Inc.)

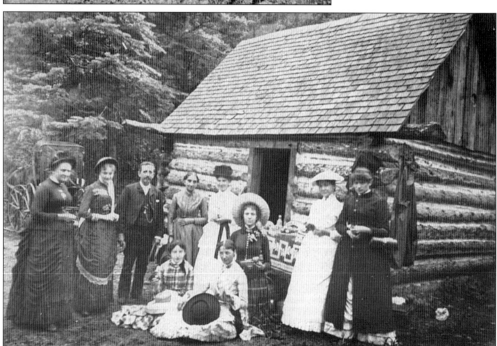

John Hay and John Nicholay, who had served as Secretaries to the late President Lincoln throughout the Civil War, came to this tiny cabin in Crystal Park, just above Manitou Springs, to write a very successful biography of their famous employer. The Hay cabin became an early tourist attraction, but eventually fell into disrepair.

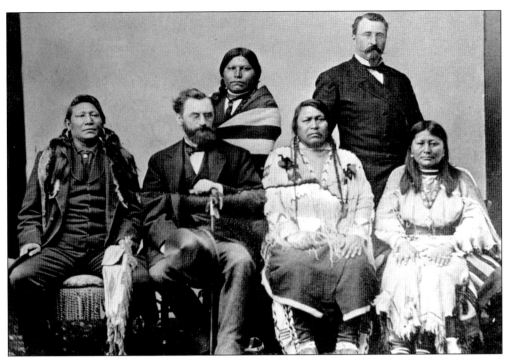

Gen. Charles Adams, seen standing on the right, was another famous Manitou Springs regular. He served many years as a successful Indian agent, brokered the release of hostages after the Meeker Massacre, engineered the capture of Colorado cannibal Alferd Packer, and served as U.S. Ambassador to Bolivia. He stands next to Ute Chief Norteeg, while Chief Ignacio, the Honorable Carl Schurz, Chief Ouray, and his wife Chipeta sit in front. (Courtesy Colorado Springs Pioneers Museum.)

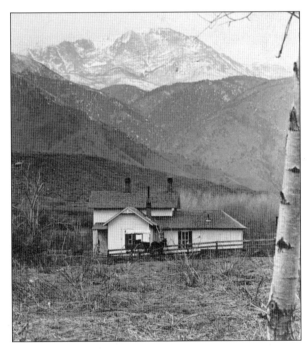

General Adam's home, named Chipeta after Chief Ouray's wife, was located between Manitou Springs and Old Colorado City. The Adams family enjoyed the social life of the nearby resort and the General had many investments there. Margaret Adams was the only woman allowed to gamble at the exclusive Hiawatha Gardens. The intersection where their home once stood is still known as Adam's Crossing.

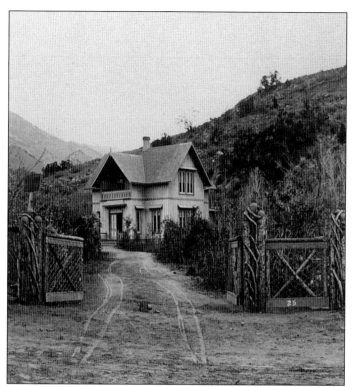

One of Manitou Springs' most illustrious visitors in the early years was the famous author Sara Jane Lippincott, otherwise known as Grace Greenwood. She was a poet, abolitionist, and feminist, but was best known as a writer of personal travel books, which is why she came to the area in 1872. The Colorado Springs Company gave her a prime villa lot and on it she built her "Clematis Cottage" which won recognition in the Ladies Home Journal. (Courtesy Historic Manitou, Inc.)

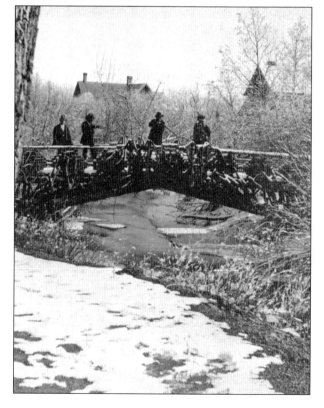

The caption of this odd stereoview taken by James Thurlow is "Shooting Beavers near Grace Greenwood's Cottage." The roof of her house can be seen above the gentlemen's heads and the roof of the beaver lodge is in the lower right. The American Fur Company had an office in Manitou Springs, so it can be assumed the animals had a price on their furry heads.

Mrs. Greenwood was the best unpaid promoter Manitou Springs had. She wrote a book about her travels in Colorado and penned many articles in the *New York Times* about the scenic splendor of the region. She held public readings for charity and was one of the honored guests at the opening of the summit weather station on Pikes Peak. She only stayed at her cottage for two summer seasons, but attracted many artists and writers to the area. (Courtesy Historic Manitou, Inc.)

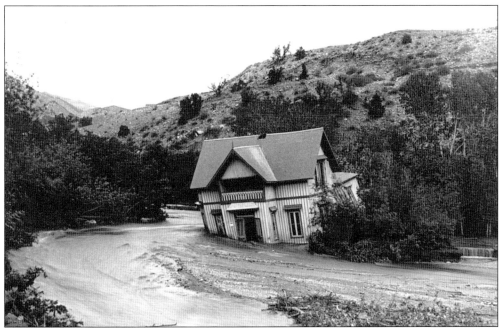

By the late 1870s, the Grace Greenwood Cottage was being rented to summer visitors and the owner was rarely heard from as she traveled across the world. Unfortunately, in the 1894 flood of Fountain Creek, this little piece of history floated off its foundations and present day Mansions Park now occupies the site. (Courtesy Colorado Springs Pioneers Museum.)

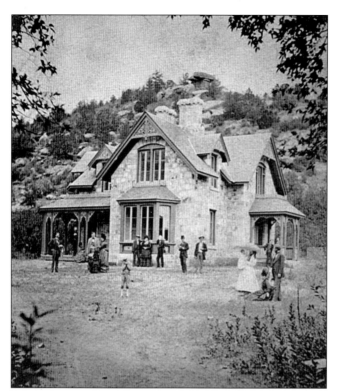

Manitou Springs' most prominent citizen, Dr. William Bell, started work on his English-style stone villa in 1872. Unfortunately he could not supervise the construction, as he had to return to England to get married. His wife Cara quickly acclimated to the rough lifestyle of the American West and made Briarhurst, the couple's new home, a social center for the new town. (Courtesy Historic Manitou, Inc.)

Cara Bell gladly moved to Colorado, but on one condition: she insisted that her children be born in England. Considering the very long journey that required, one can imagine the determination of this lady. When their first child, Rowena, was to be brought to Briarhurst from England, the employees decided to erect a welcoming arch to greet the new arrival. The sign reads in part "Welcome Sweet Babe." (Courtesy Colorado Springs Pioneers Museum.)

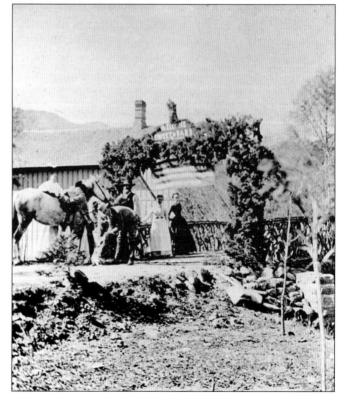

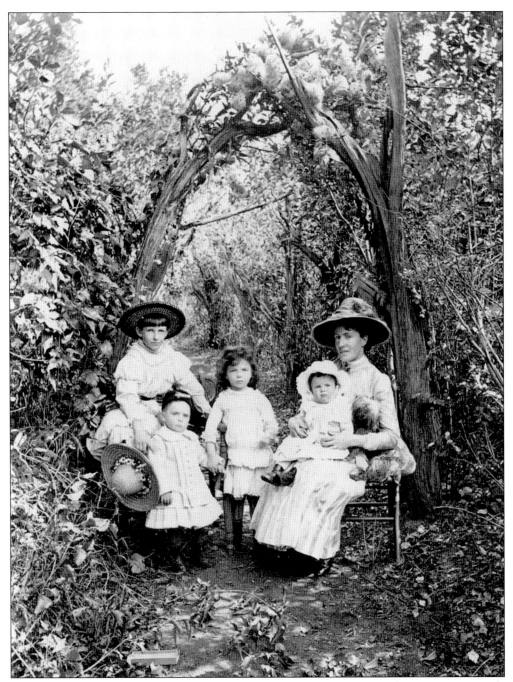

In early Manitou Springs the style of landscaping was definitely xeric as there was no citywide water system to artificially irrigate with. Dr. Bell went to great effort to plant numerous locust and silver maples trees that required little moisture and grew quickly. Wild clematis and prickly shrub roses were native to the area and the town's designer, John Blair, encouraged their use. This portrait of Cara Bell and her daughters was taken on Lover's Lane—a picturesque walking path between the Manitou House and the Cliff House that was draped in wild clematis and dotted with rustic benches and romantic arches. (Courtesy Colorado Springs Pioneers Museum.)

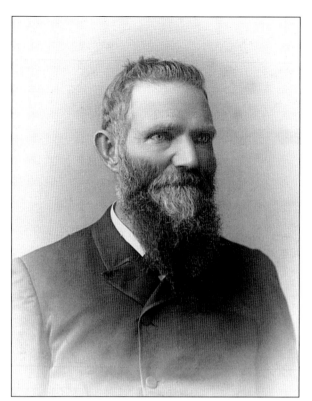

The business community of Manitou Springs was well represented by Dr. Isaac Davis, who, having fought for Queen Victoria and Abraham Lincoln, arrived in 1872 to fight for his own health lost during the Civil War. He succeeded admirably and went on to start the first pharmacy and city cemetery. He served as county coroner, post master, local mortician, and he developed the slopes of Red Mountain for housing. He also found time to be a father to 15 children. (Courtesy Carol Davis Warner.)

Sarah Davis must have contributed greatly to the success of her husband. A native of Great Britain, she immigrated with Isaac and their family to New York, though they lost two children on the passage. Sarah persevered during the Civil War and her husband's medical schooling to eventually homestead in a log cabin in Manitou Springs. The family prospered and some of Isaac's siblings joined them in Colorado. (Courtesy Carol Davis Warner.)

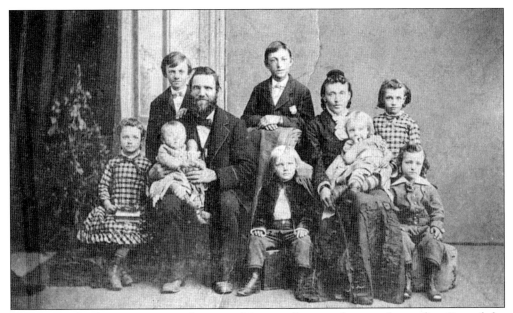

This Davis family portrait was taken in a Manitou Springs photography studio. One of the Davis boys is believed to be the first child born in the new town, even though "Manitou" Arthur James is usually given credit for that honor. Many of the Davis children stayed in the area after marriage, creating a dynasty of sorts. (Courtesy Carol Davis Warner.)

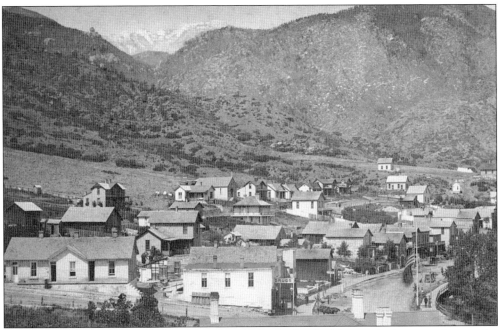

Dr. Davis' first pharmacy was located in the white wooden building with three windows at the bottom of this photograph. It was one of the first commercial buildings in the downtown and sat where the present day library is today. His son, William A. Davis, eventually took over that business, as his father was busy with other duties. By 1887, the Doctor built a grand brick and stone edifice on Cañon Avenue, which still stands today.

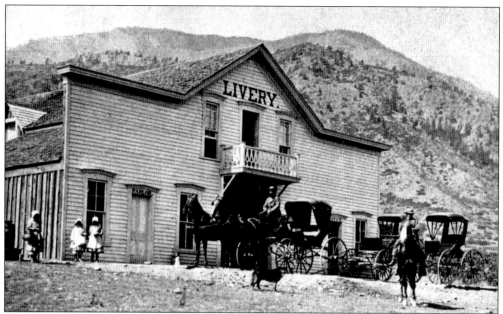

This was the first livery stable in Manitou Springs, erected by Messrs. Swisher and Holmes. Started in late 1872, the building contained areas for carriages, stables, and a business office. Unfortunately, in March 1873, it no longer had a front façade, which blew down in a windstorm and had to be rebuilt. It sat on the south side of Manitou Avenue, just east of the Manitou House. (Courtesy Colorado Springs Pioneers Museum.)

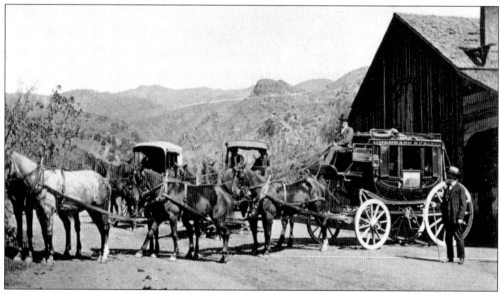

Early resentment simmered over the name "Colorado Springs," when the actual springs were in Manitou. Residents and businesspeople in the smaller town felt ill-used with the terrible condition of the road visitors had to travel over to reach them. With no alternate transportation forthcoming, the road between the rival towns was always very busy with the daily stagecoaches, as seen here, plying their way over numerous potholes and washed out bridges. (Courtesy Colorado Springs Pioneers Museum.)

For entertainment in early Manitou Springs, nothing could beat the Park Skating Rink, seen in the background of this photograph, c. 1885. Both sexes enjoyed the activity: men because they could catch the glimpse of a lady's ankle during a tumble, and women because they could ask a gentleman's aid in getting up. The local newspaper claimed that the falls at the park could outdo those at Niagara.

This late 1875 view shows Max Weniger's grocery store on the left and the Manitou Livery on the right. Both were located on the southern side of Manitou Avenue, directly opposite the Navajo Spring. These types of businesses served the needs of locals and tourists, as well as the miners and settlers using the Ute Pass Road to travel to other parts of the state.

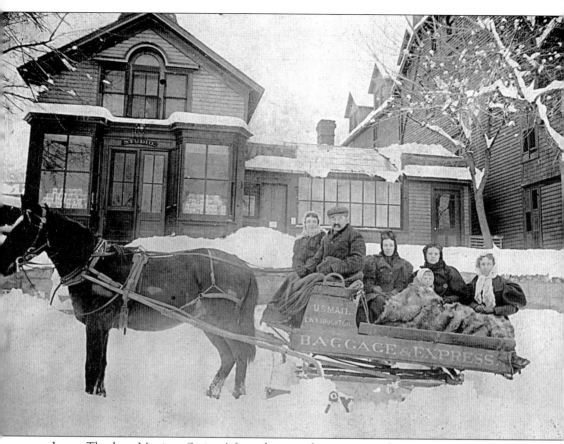

James Thurlow, Manitou Springs' first photographer, came to the area in 1874 from Illinois. Known originally as a portrait artist, his tastes and talent steered him towards capturing the beauties of the Pikes Peak region. He built a home and studio on the west end of Manitou Springs near the Ute Pass Road, enabling him to record the passage of travelers heading for the high country. In the summer of 1878, Thurlow built the more centrally located studio seen in this view, next to the Barker House. He tragically died on Christmas Day, 1878. His wife Alice eventually sold her husband's negatives to Charles Weitfle, who reprinted them under his name. This studio became home to most of Manitou Springs' subsequent photographers until it was demolished for a drilled spring pavilion. The horse-drawn sleigh, shown with the Broughton family in tow, delivered the mail in wintertime. (Courtesy Diane Coates.)

This is one of Thurlow's business cards: a scene more reminiscent of an English hunting party than the American West. Perhaps he was trying to appeal to the gentrified British residents of Colorado Springs, which was then known as "Little London." During his short Colorado career he was known as a superb technician as well as an artist. He often included himself in a scene to convey a sense of scale. (Courtesy Historic Manitou, Inc.)

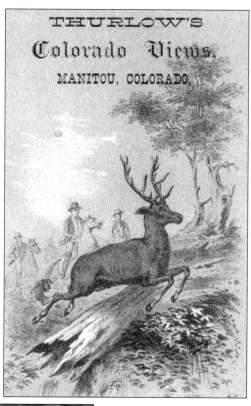

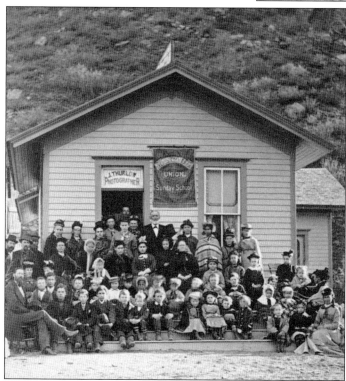

James Thurlow took an active role in the government of his adopted town, serving as Justice of the Peace and a signer of Manitou Springs' incorporation papers in 1876. His generosity included holding Sunday school meetings at his home, as seen in this view, where Mr. Thurlow is believed to be the gentleman sitting on the left. His sudden death shocked the citizens and they issued a proclamation of sympathy in the local newspaper expressing their grief and admiration. (Courtesy Historic Manitou, Inc.)

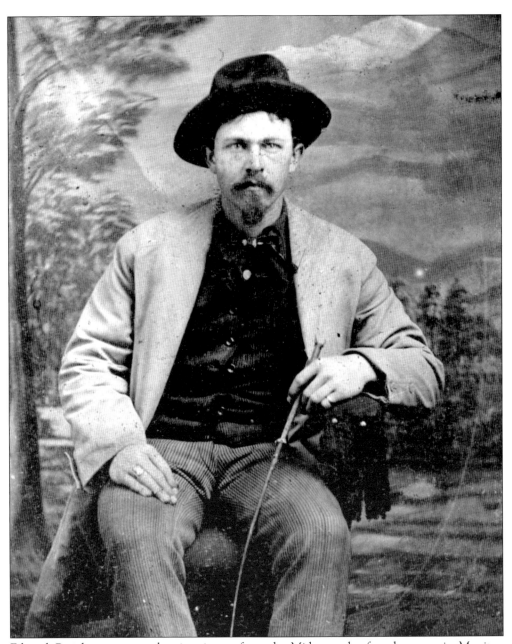

Edward Creighton was another immigrant from the Midwest who found success in Manitou Springs. He arrived in the late 1870s, sick with tuberculosis, but open to opportunity. He ran a successful bowling alley next to the Manitou House, and then opened a saloon called The Arcade. Colorado Springs was a dry town, so establishments serving liquor always did well. Creighton also served many terms as a town trustee and as chief of the local volunteer fire department. When gold was found in Cripple Creek Ed was still adventurous enough to try his hand at mining, though he didn't live long afterward. This daguerreotype of Creighton, sitting confidently in front of a painted backdrop of Pikes Peak, was perhaps sent home to lure his family to Colorado. All four of his brothers in Ohio eventually contracted tuberculosis and did make the move to Manitou Springs. (Courtesy Deborah Harrison.)

Two

NATURE'S GIFTS

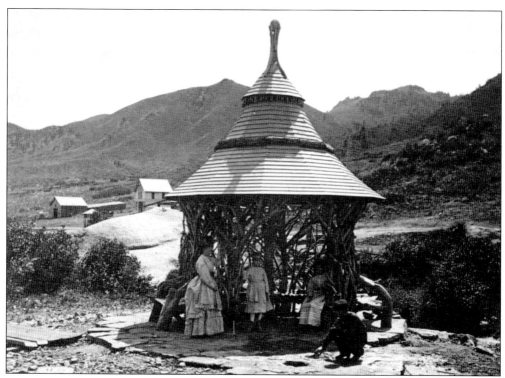

The springs of Manitou were the nexus for all early development in the area and the Manitou Soda Spring, seen here, was the most popular. The pavilions were usually set next to the springs to provide a shady resting place for invalids, women, and children. (Courtesy Historic Manitou, Inc.)

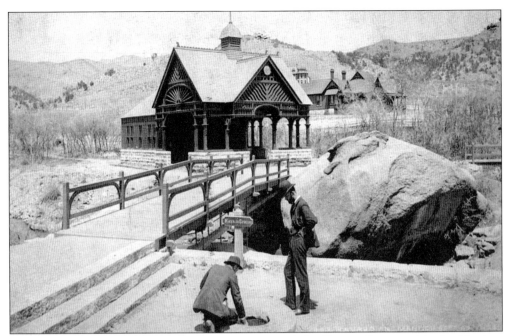

These gentlemen are enjoying the delicious waters of the Navajo Spring, with the Manitou Soda Pavilion in the background. This imposing structure was built in the summer of 1885 to replace the rustic gazebo, which was deemed unfashionable by the growing town. The pavilion became the focal point for the newly organized Soda Springs Park, extending from the Wheeler Town Clock to the end of Park Avenue. (Courtesy Historic Manitou, Inc.)

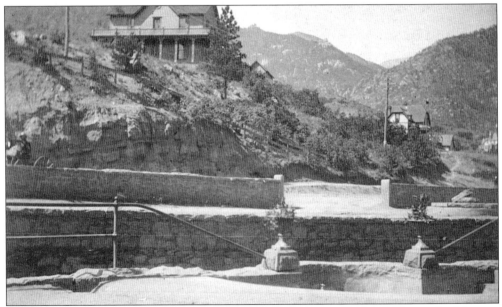

As Manitou Springs grew in popularity, thousands of visitors arrived each day at the Manitou Soda Spring to take the waters and enjoy the pleasant surroundings. To relieve the congestion another drinking area was added on the street side of the pavilion, as seen in this rare view. Visitors would descend a short flight of stairs from the ground level to reach the water.

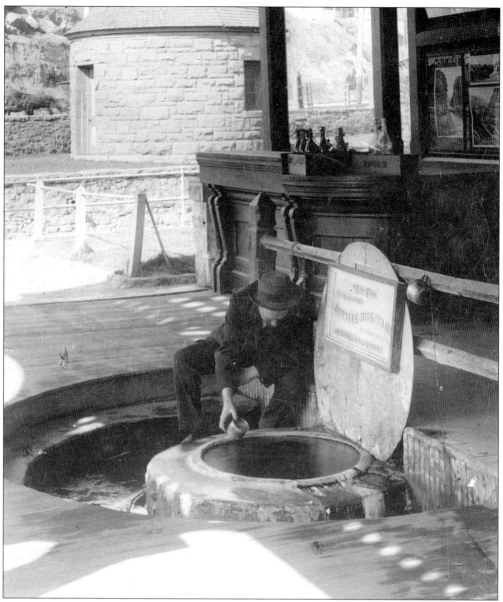

William A. Davis, who was no relation to Dr. Isaac Davis or his son, owned the concession rights to the Manitou Soda Pavilion and sold mineral water, lemonade, curios, photographs, and Native American jewelry from this location. His brother, R.M. Davis, was a well-known photographer in Denver and supplied images for the family business. In this picture, the Cheyenne Spring Pavilion can be seen in the background, where it still stands today. Part of the sales counter is visible on the right, with posters from various scenic tours available and empty bottles for 25¢ to fill up with spring water. The spring itself seems pretty insignificant, with its wooden cover reading, "$5.00 Fine for filling bottles, jugs and pails at this spring, go to the pipe outside."

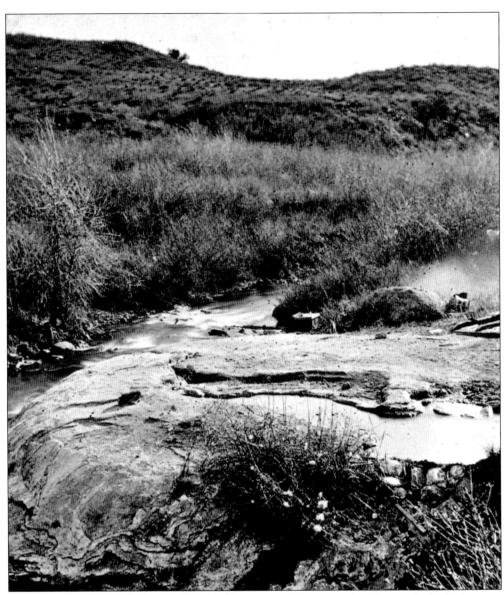

Though the Manitou Soda may have held a premier location, the Navajo Soda Spring was considered the finest tasting and most effervescent. In this view, the centuries of overflow into the Fountaine qui Bouille can be seen in the sloping bank of mineral deposits. Though it was never specified, this is probably the spring that English explorer George Frederick Ruxton first tasted on his trip through the area in 1846. He already knew the excellent reputation of the waters and had abstained from drinking all day to better appreciate their flavor. After drinking three times without taking a breath, Ruxton described the experience as "almost blowing up the roof of my mouth with its effervescence," and the taste as "that fresh, natural flavor which manufactured water can not impart." (Courtesy Colorado Springs Pioneers Museum.)

Being closest to Manitou Avenue, the Navajo Spring was the most frequented and most taken for granted. Only a concrete basin was provided and, when a grander pavilion was planned for the Manitou Soda, the old rustic one was dumped next to the Navajo. No matter how unadorned, the little boys in this view must have appreciated the fizzy waters. (Courtesy Historic Manitou, Inc.)

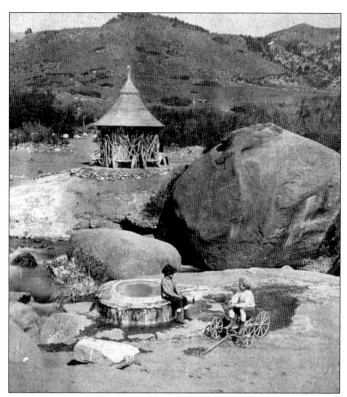

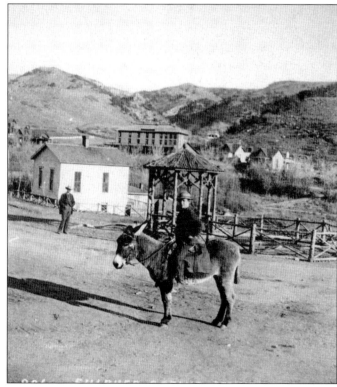

This young burro rider is having his picture taken in front of the Shoshone Spring and the new bottling works to the left. A primitive effort at containing the highly gaseous mineral water in jugs had been attempted in the old bath house, but this enterprise was the first to try glass. Due to the high cost of importing bottles that could stand the pressure, this effort was never a moneymaker. (Courtesy Historic Manitou, Inc.)

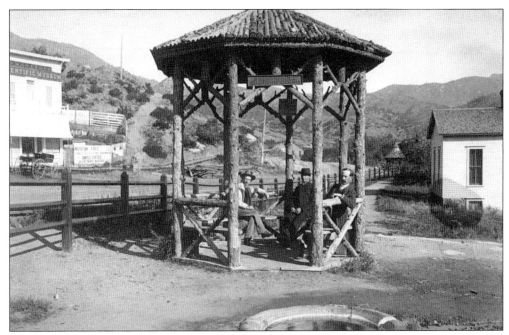

The Shoshone Spring, located half a block east of the Navajo Spring, was very popular with doctors, who appreciated its high sulfur and radium content. After all, if it tasted bad, it might be good for you. The local farm animals and wildlife were especially fond of the salty accretions around the basin, so a stout fence had to be erected around it to protect the waters for human consumption.

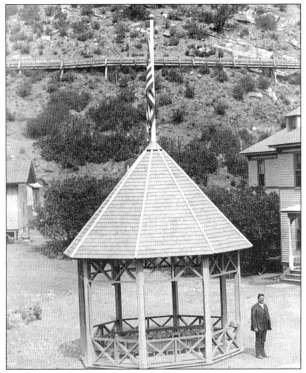

At the western end of Manitou Springs was another grouping of springs, of which the Hiawatha was the most popular. The name fluctuated with the owners, but by the late 1890s Jacob Schueler had purchased the property and decided on "Ute Chief." Once in partnership with Adolph Coors, Schueler felt beer brewing had a limited future and turned to water. He built a bottling facility and started the successful Ute Chief Mineral Water Company, though he may have underestimated the potential of his former partner.

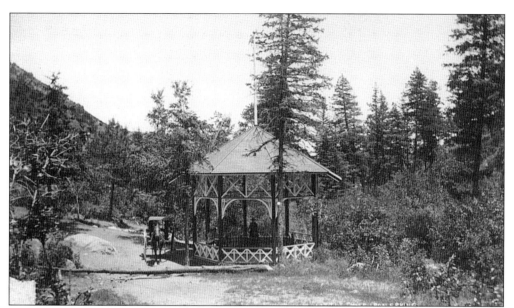

There was a very popular cluster of iron springs located in the valley of Ruxton Creek, southwest of downtown Manitou Springs. It became the fashion to stroll up the Avenue in one's finest clothes to take the waters in this picturesque woodland setting. The most distant was the Little Chief, seen here under its large open pavilion. As it was situated along the beginning of the Pikes Peak Trail, it also served as a perfect place to gather before taking on the long climb. (Courtesy Historic Manitou, Inc.)

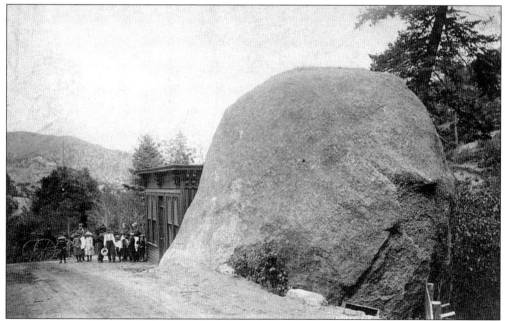

The first iron spring on the stroll up Ruxton was the Big Indian, which sat next to Indian Head Rock, seen in this view. The building could be the studio of Windy Jones, who took advantage of his location to sell views and curios to the many passersby. This spring was on the edge of the iron water cluster and was apparently higher in soda content than the others.

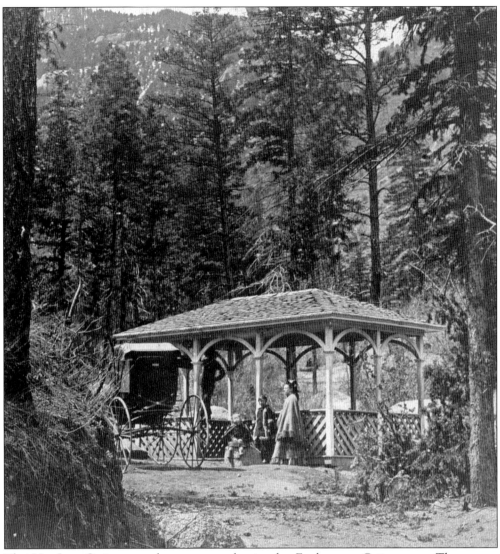

The Ute Iron Spring was the most popular in the Englemann Cañon area. The names Englemann and Ruxton were apparently interchangeable in the early years. The former was a naturalist who discovered many of the flora in the area, and the latter was George Frederick Ruxton, the explorer. The waters of the Ute Iron, originally found within Ruxton Creek, were heavily laden with minerals and not to everyone's taste. Local doctors thought the taste was nothing compared to the wondrous health benefits and prescribed it often. The tourists probably benefited as much from the healthy walk up Ruxton Avenue and the peaceful, treed setting. (Courtesy Historic Manitou, Inc.)

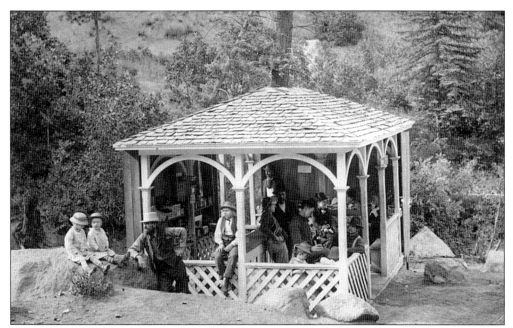

Dr. Strickler originally developed the Ute Iron Spring for the sole benefit of his guests at the Iron Springs Hotel and charged others. This policy was quite controversial and nobody tried to profit directly from the source of the waters for another 30 years. In this view you can see an attendant in a white apron towards the back and boxes of curios and photographs for sale on the left wall. (Courtesy Historic Manitou, Inc.)

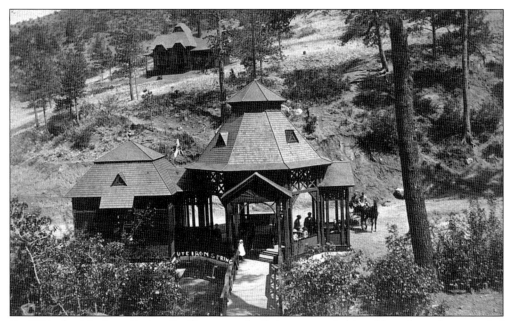

By 1884, the Ute Iron Spring Pavilion was rebuilt in a more fashionable style and surrounded with picturesque summer cottages built by a consortium from Michigan. This building became the model for a new pavilion built in the 1990s in Seven Minute Spring Park. (Courtesy Historic Manitou, Inc.)

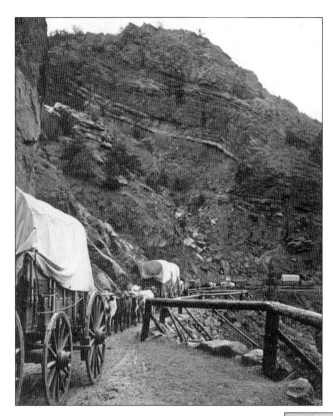

The Ute Pass Road had long been a shortcut to the mining areas of the Continental Divide. With the silver boom in Leadville the road became a crowded highway of trade and emigration. Unfortunately, it was so narrow in a section just west of Manitou Springs that the traffic could only travel one way at a time. This J. Thurlow photograph shows a wagon train slowly winding its way up the pass. (Courtesy Historic Manitou, Inc.)

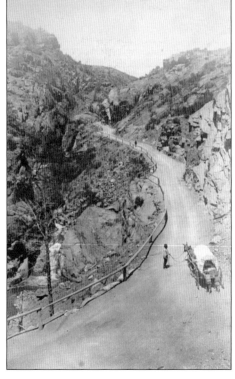

This later view of the Pass shows the still narrow road flanked on the left by some of the waterfalls that attracted so many visitors to the area. There were also a few springs between the Manitou Springs city limits and the Pass, like the Pump and the Captain. Once the railroads forged new lines into the burgeoning mining areas, the road was mainly used by tourists. (Courtesy Historic Manitou, Inc.)

James Thurlow took this photograph on the Ute Pass road near his home and studio, with Iron Mountain in the background. The group of travelers, according to the title "San Juan or Bust," is apparently part of the great migration of gold seekers to the newly opened claims in the San Juan Mountains of southwestern Colorado.

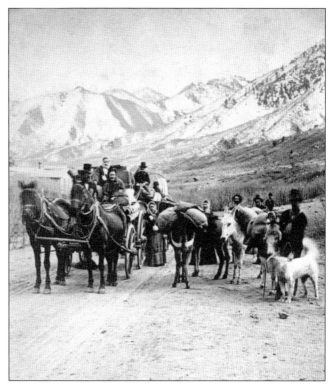

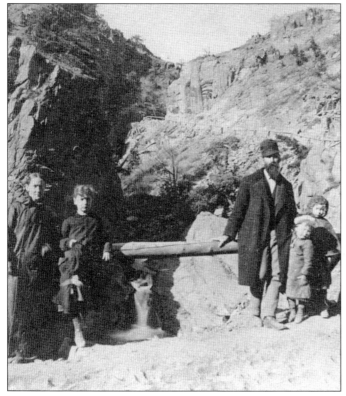

This image of Ute Pass shows a tourist family enjoying the scenic view of a Fountain Creek waterfall from the road. Unseen are the flimsy poles that held up the railings upon which they are leaning. Safety was definitely not regulated by the government back then, but most accidents in Ute Pass were caused by runaway horses or rockslides. (Courtesy Historic Manitou, Inc.)

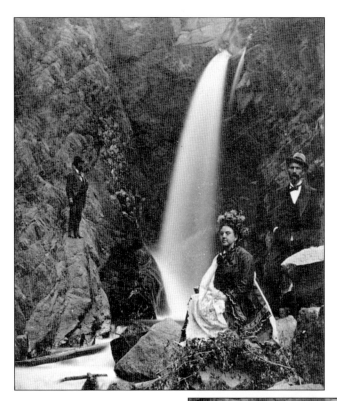

There are many small cataracts along Fountain Creek as it rushes through Ute Pass, but Rainbow Falls was by far the largest and most picturesque. The rainbow was created by the refraction of light in the spray at the base. People were so taken with the display that many photographers felt obliged to add the rainbow to their images even though they were in black and white. (Courtesy Historic Manitou, Inc.)

Since early camera equipment was cumbersome and difficult to set up, many photographers would take a series of shots to maximize their time outside of the studio. These Weitfle images are actually from Thurlow negatives and Mr. Thurlow himself is probably the man standing on the left side of the waterfall. (Courtesy Historic Manitou, Inc.)

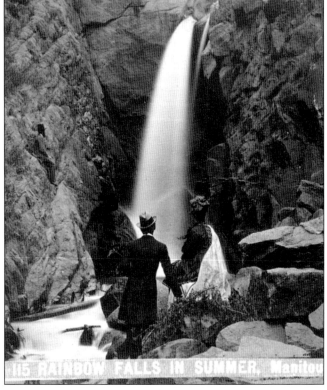

115 RAINBOW FALLS IN SUMMER, Manitou

Sometimes waterfalls in the Rocky Mountains are even more spectacular in the winter. This Gurnsey view shows Rainbow Falls in all its icy glory in the 1870s. Since most tourists came to the area in the summer, these images must have been a popular curiosity. (Courtesy Historic Manitou, Inc.)

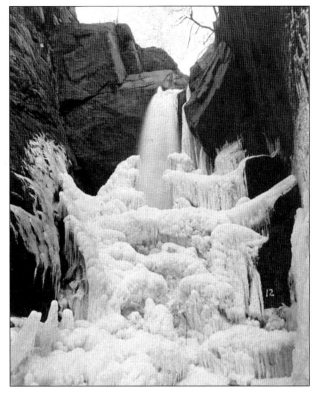

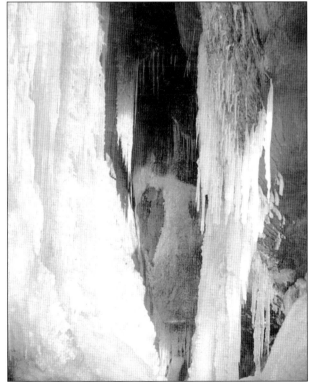

Good photographers of the day understood the importance of perspective. Here, William Hook has concentrated on the play of light on a tightly focused portion of a frozen Rainbow Falls. Whether his artistry was appreciated by the throngs of summer tourists is unknown.

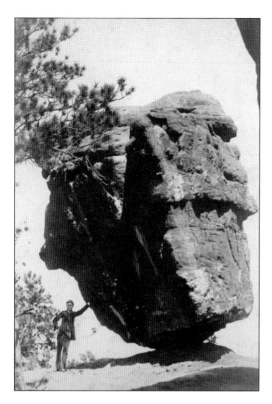

Just a buggy ride away from Manitou Springs were the spectacular Garden of the Gods rock formations, but within the city limits was Balanced Rock, so it became very popular to have one's picture taken there. This is one of the earlier versions of a photographic cliché that will probably never go out of style. (Courtesy Historic Manitou, Inc.)

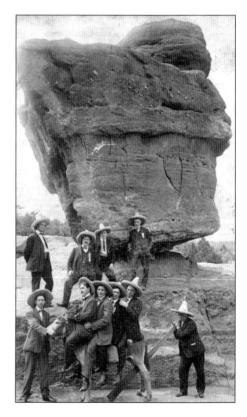

The photographer Paul Goerke bought the property in the early 1900s and fenced it off so that visitors would have to pay for an exclusive photo taken on burros, wearing his unusual hats.The City of Manitou objected and won in the courts. This Goerke image seems to prove another universal theory held by women: males traveling in packs exhibit unusual behavioral patterns. (Courtesy Historic Manitou, Inc.)

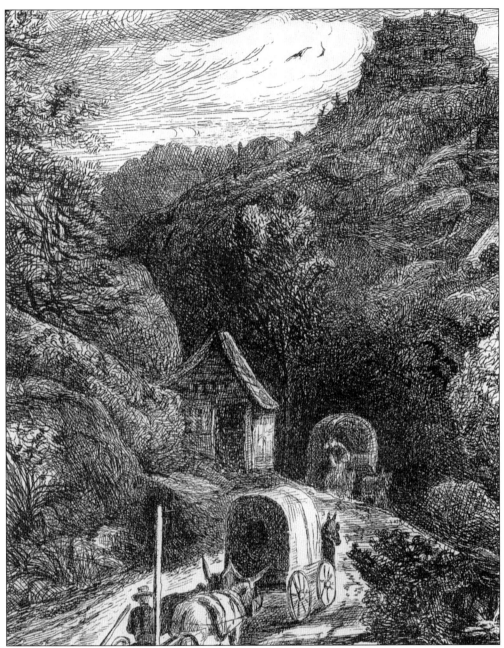

Eliza Greatorix, the New York artist and illustrator, probably came to Manitou Springs at the bequest of Grace Greenwood, who wrote the introduction to her friend's book of etchings. Each of Mrs. Greatorix's pictures is accompanied by an interesting story about the scene. The focus of this illustration was the small building, which apparently served as a bakery and eatery, run by an English couple who specialized in antelope pasties. This view of the Ute Pass Road also highlights the unusual rock formation known as Tim Bunker's Pulpit, in honor of the Reverend Mr. Clift, who apparently wrote under this pen name. Victorians had a peculiar pleasure in naming every formation, which was quite an accomplishment, considering how many large rocks there are in the area. (Courtesy Historic Manitou, Inc.)

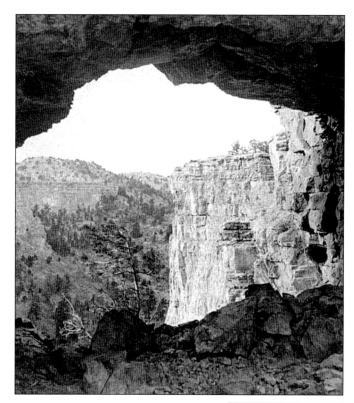

William's Cañon, named after a New York journalist, provided the Victorians with a never ending display of geological wonders. The cause of such impressive erosion was a tiny little creek, though it grew much larger during floods. The Temple of Isis was a curiosity within the canyon that most viewed from below, but this photographer decided to capture a different perspective. (Courtesy Historic Manitou, Inc.)

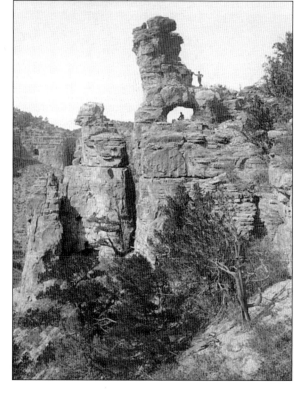

This is the Temple of Isis from the typical vantage point. You can see how the photograph above required a good deal of fortitude on the part of the cameraman. In this view, some brave souls have hiked their way to the opening for the sake of a good picture. Local photographers were always asking Manitou Springs residents to pose for views to sell to visitors. (Courtesy Historic Manitou, Inc.)

This constricted portion of the William's Cañon road was called The Narrows or the Card Rack, rivaling Balanced Rock as the most photographed location in the area. In this shot William Hook captures the scale of the formation using his son Willie. Hook was always an artist even with the most mundane of subjects. (Courtesy Historic Manitou, Inc.)

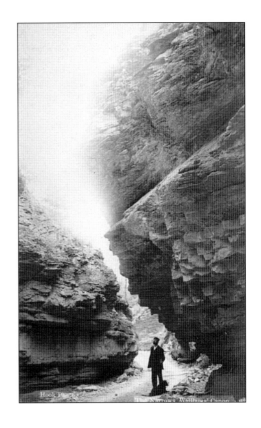

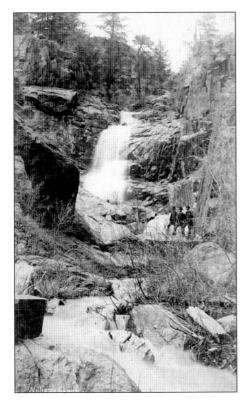

Long walks in the fresh air were often prescribed by local doctors and Manitou Springs abounded with them. Health seekers and tourists who had the stamina to hike the length of William's Cañon received a prize at the end of their journey. This delicate waterfall was admired by all who found it. (Courtesy Historic Manitou, Inc.)

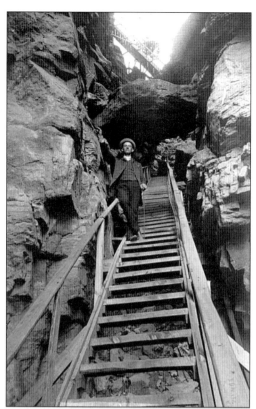

Manitou sits over a fault line and at the intersection of three major valleys. The geographic forces and power of water have created a large number of caves in the area, most on the north side of the town. The Cave of the Winds has always been the most visited of these, but access difficulties must have put some visitors off.

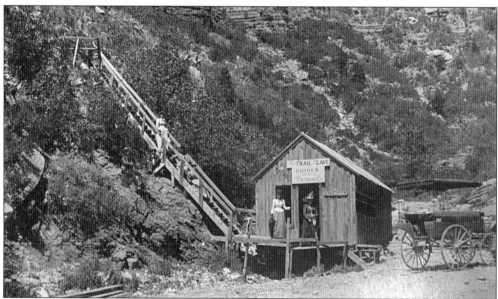

The original entrance to the Cave of the Winds had been discovered by Arthur B. Love, a homesteader, around 1871. At that date, there was nobody else to show it to, so the cave was left to be rediscovered a few more times. By the 1880s, Manitou was on its way to becoming a destination resort and plenty of visitors were willing to buy a ticket from this booth and hike the stairs to see a natural wonder.

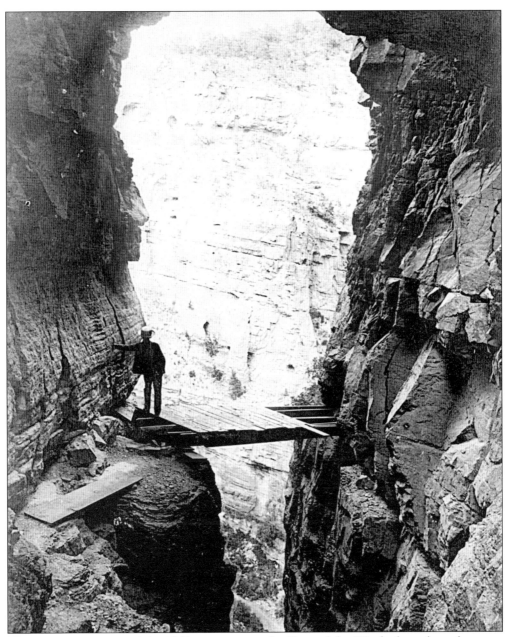

This impressive image of the 1880s entrance to the Cave of the Winds shows how the name might have been conceived. According to George Snider, the photographer James Thurlow deserves credit for the lyrical title, maybe after listening to the famous Colorado breezes whipping through this opening. Many early settlers claimed discovery rights to the cave, but George Snider and Charles Rinehart had the foresight to buy the property in 1881, improve, and widely promote it as a tourist attraction. Unfortunately for George, money had to be borrowed from his family and the subsequent tale of lawsuits and brotherly betrayal took on the proportions of a Shakespearean tragedy. Eventually, George ended up with nothing but the will or spite, depending on your point of view, to write his book, *How I Found and Lost the Cave of the Winds*. (Courtesy Historic Manitou, Inc.)

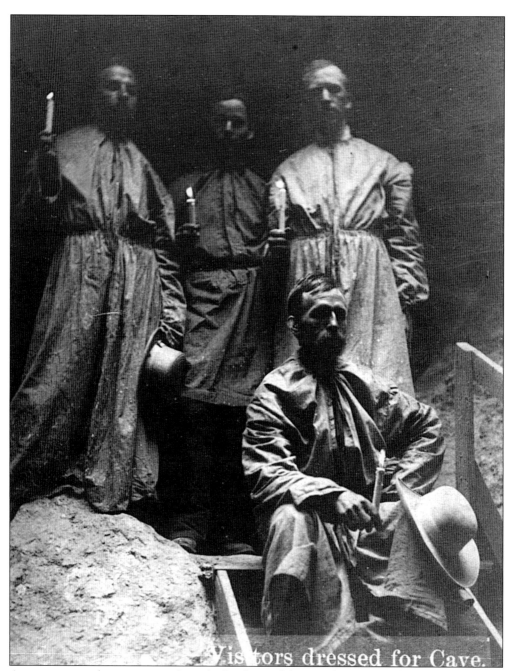

Visitors dressed for Cave.

A mysterious and exciting trip through the Cave of the Winds was considered a must for the average tourist during the 1880s. Though this view shows only men, women also enjoyed donning the oilcloth raincoats and floppy hats required to maintain one's decorum while delving into the bowels of the earth. After all, if a woman could negotiate her way up the rickety stairs to the elevated entrance wearing high-top boots and long, woolen skirts, she could probably be trusted to not embarrass herself in the cave.

George Snider relates in his book that he discovered some previously hidden rooms full of stalactites in the cave system that convinced him to buy the property. While he was gone for the day, the whole town heard about it and stripped the rooms clean for souvenirs. This view shows the Music Hall, which proves that some interesting formations were left after the initial hysteria.

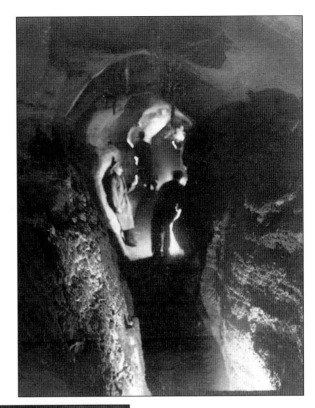

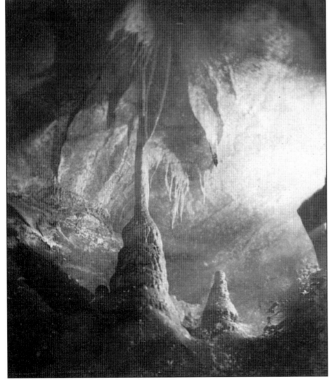

Early photographers had to overcome many challenges to capture an image of the caves. In the local newspaper, William Hook is described as setting up phosphorus lamps that virtually exploded to create enough light for picture taking. His views were commissioned for a magic lantern slide show. This atmospheric picture is by William Henry Jackson, the premier western photographer, who must have used similar devices.

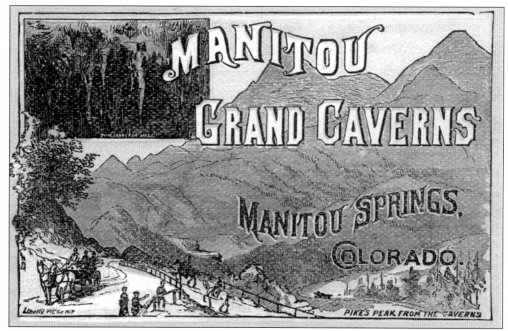

The Manitou Grand Caverns was another, separate system of caves adjoining and overlapping the Cave of the Winds. George Snider ended up running this business after further family deal making and lost it the same way. However, for a few years, the Grand Caverns were heavily promoted and very successful. This booklet, which dates from around 1885, was widely distributed. (Courtesy Historic Manitou, Inc.)

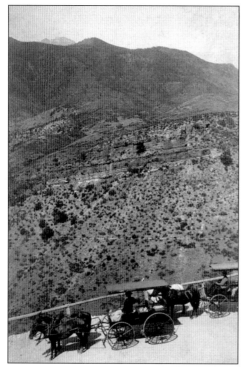

George Snider built this road to the Manitou Grand Caverns to provide easier access and spectacular views. The road was a complete success and took business away from the other cave for awhile. During its construction, Snider and his wife lived in a cabin nearby and were almost killed one night when a mountain downpour set off a large land slide of boulders that demolished their home.

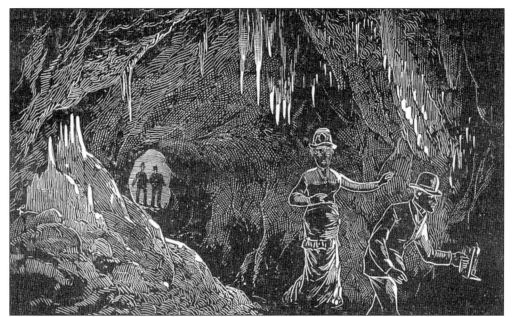

Snider considered the Grand Caverns to be even more spectacular than the Cave of the Winds.
Certainly, it had never been vandalized in the same manner. This view of The Narrows gives
the impression that visitors could enjoy the cave unattended, but guides were always a necessity
in a world lit only by candlelight. (Courtesy Historic Manitou, Inc.)

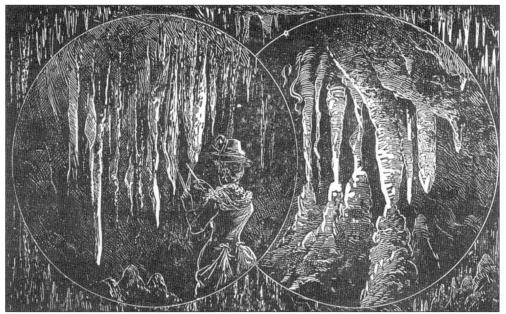

One of the special features of the Manitou Grand Caverns was a stalactite organ, played by
using a special hammer to strike specific formations that corresponded to different musical
tones. Unfortunately, this effect can no longer be created as some of the stalactites have broken
off. (Courtesy Historic Manitou, Inc.)

The greatest natural attraction in the Manitou Springs area is Pikes Peak. Though not the highest in Colorado, the mountain is the first hint of the Rockies one sees when arriving from the east. It was an ever-present backdrop to most pictures and, if the angle wasn't pleasing, photographers simply moved it to a better position. Here, it occupies its correct location, as seen from Dr. Bell's rustic bridge. (Courtesy Historic Manitou, Inc.)

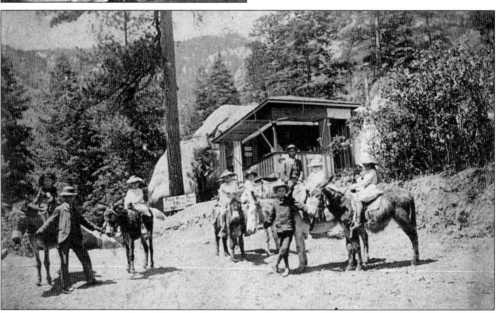

Just as it drew its namesake, Pikes Peak acted as a beacon to all visitors, challenging them to attain its summit. The great pathfinder, John Fremont, blazed one trail to the top, and the Army Signal Corps built another, but the most accessible was the Pikes Peak Toll Road. Seen here is the small booth where the tolls were collected and advice given before the intrepid riders set off. Probably the only one who didn't make it to the top was Zebulon Pike himself, who claimed the mountain would never be climbed.

Along the course of Ruxton Creek, as it crosses the Pikes Peak trail, there are several impressive water features. The Hidden Falls must have brought the greatest pleasure to those who could find it. These gentlemen were so impressed with their achievement that they convinced photographer William Hook to record the occasion. Alternatively, since Mr. Hook lived on the slopes of the Peak, he may have let them in on the secret. (Courtesy Historic Manitou, Inc.)

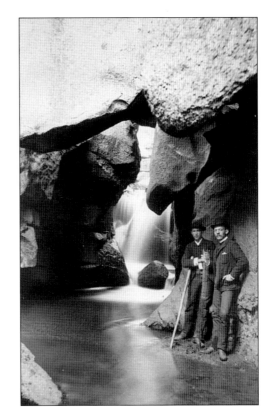

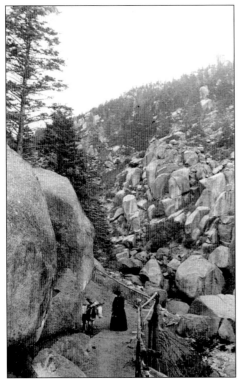

This lone lady is admiring the view from the trail and she is probably feeling quite pleased with herself, but she was certainly not the first woman to climb Pikes Peak. That honor falls to Julia Archibald Holmes, a bloomer girl from Kansas, who didn't let little things like a corset or members of her party stop her from accomplishing her goal in 1858. (Courtesy Historic Manitou, Inc.)

59

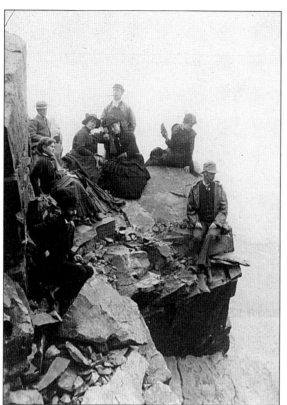

These daring tourists have reached the summit of Pikes Peak and are sitting back to enjoy the view, though one lady is enjoying it as far away from the precipice as she can. One has to wonder how the photographer felt about heights. (Courtesy Historic Manitou, Inc.)

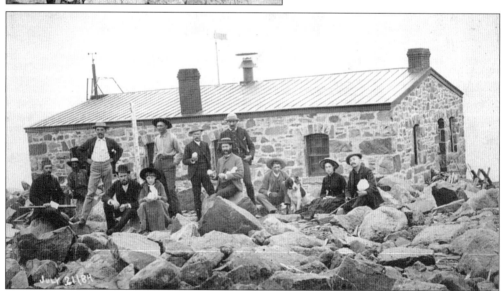

Since the summer of 1873, the Army Signal Corps had maintained a weather observatory at the summit of Pikes Peak. The station was manned at all times of the year with only an often repaired telegraph line connecting it to the city of Colorado Springs. The posting was quite dangerous as the location was battered by lightning storms and raging blizzards. The antics of thousands of tourists may have relieved the tension, though sometimes they would confuse the observatory with a hotel. (Courtesy Historic Manitou, Inc.)

Sgt. John O'Keefe was one of those Signal Corps officers who liked to entertain the tourists with outlandish stories of volcanoes erupting and herds of mountain lions attacking. His greatest whopper, about his invented family being attacked by vicious mountain rats who ate his imaginary infant, was picked up by a news service and soon the counterfeit gravesite of little Erin O'Keefe was attracting more attention than the fabled views. (Courtesy Historic Manitou, Inc.)

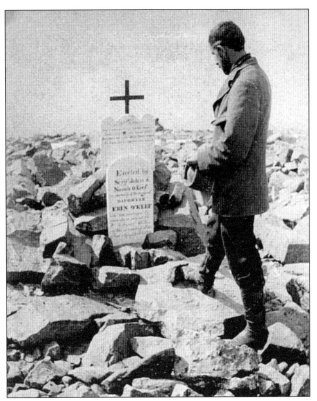

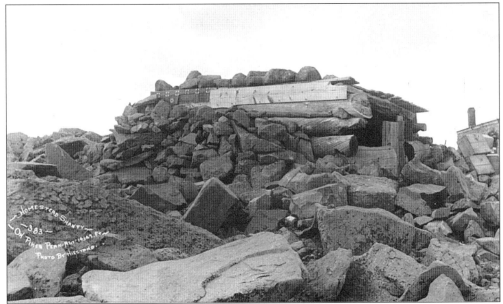

Although it looks like the perfect home for a hermit, this "shanty" was an attempt to homestead the summit of Pikes Peak in 1889. Doctor Lewis knew that a Cog railway was being planned to this point and, if he could succeed in proving habitation, the land would be his to sell at an inflated price. The government was not impressed and the Cog received the property for a reasonable sum. (Courtesy Historic Manitou, Inc.)

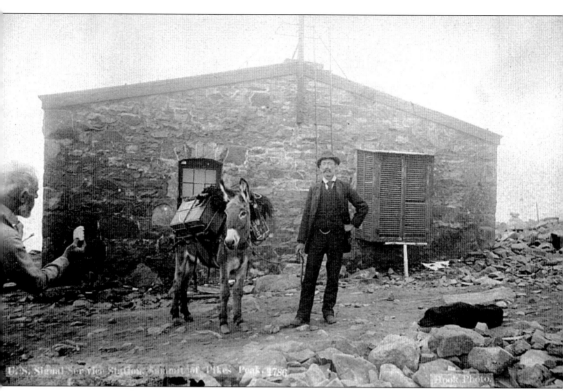

Most tourists who actually made it to the top of Pikes Peak wanted their achievement recorded. There were plenty of photographers willing to capture the moment for a small fee. This image shows an exalted climber ready to be immortalized by William Hook, who is accidentally giving away a trade secret on how to get a burro to look at the camera. Obviously the black dog in the foreground is not impressed with biscuits, even though the burro is. Of course, the tourist could never have ridden that burro up the peak with all of Hook's camera equipment on its back. (Courtesy Historic Manitou, Inc.)

Three

SARATOGA OF THE WEST THE 1890s

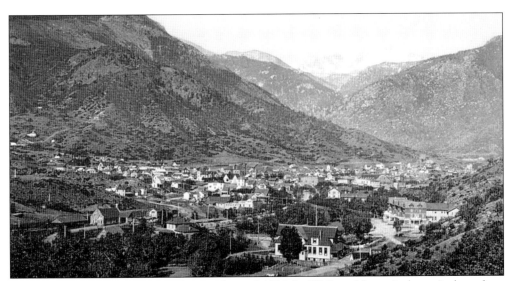

This overview of Manitou was taken in the mid 1890s by William Henry Jackson. It shows how much the little health resort had grown in the 20 years since its founding and why many called it the "Saratoga of the West." (Courtesy Historic Manitou, Inc.)

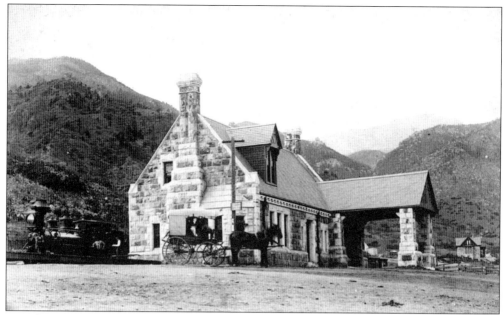

Initially Manitou Springs was without rail service and visitors had to ride the daily stagecoaches or hire private buggies. Locals howled about the terrible conditions of the roads until the Denver & Rio Grande finally added a spur from Colorado Springs in 1880. Passengers disembarked at this charming pink and white sandstone depot, which Dr. Bell had originally designed as a church. The remaining stained glass windows and pulpit must have turned a few heads.

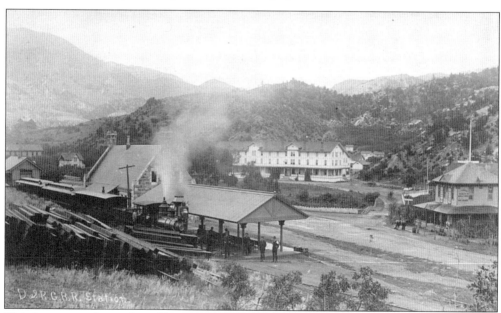

This later view shows the addition of a covered platform. Arriving visitors could stand in shaded comfort while hack drivers, who worked for the competing hotels, enticed them with noisy claims of superiority. One of the Denver & Rio Grande's petite, narrow gauge engines sits steaming at the station. In the distance is the Manitou House, and to the right is Albrecht's Saloon, whose sign proclaimed the serving of "Barley Water & Bad Cigars."

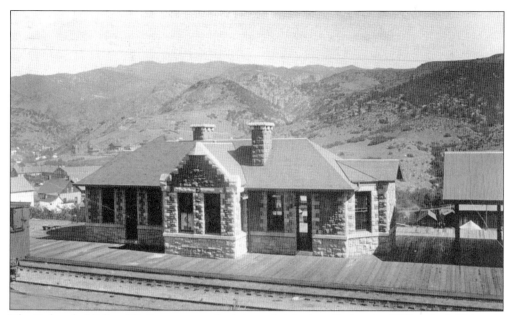

The Colorado Midland Railway was pushed through Manitou Springs in 1887, to link Colorado Springs with the booming silver fields of Aspen. The depot, seen here, was built of variegated stone and sat, as it does today, above the school property on the south side of Manitou Avenue. (Courtesy Denver Public Library Western History Department.)

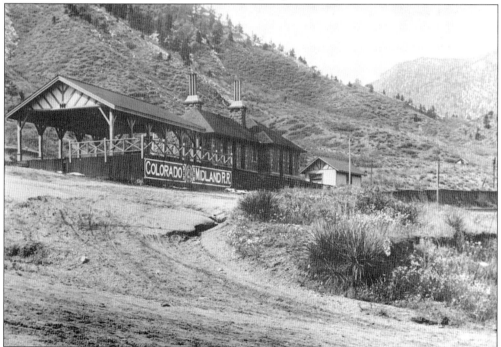

This covered passenger platform was added to the Midland depot to protect visitors from those sudden Rocky Mountain thunderstorms. Unfortunately, a torrent of red ink put the railroad into receivership in 1918, but it continued to run through Manitou Springs to Cripple Creek as the Midland Terminal until 1949.

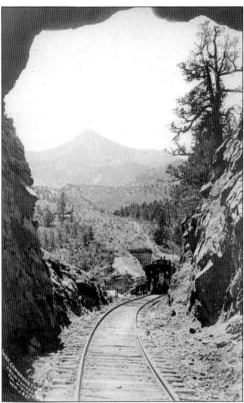

This view of Cameron's Cone from a tunnel shows why the Midland Railway was considered the most scenic in Colorado. In Manitou Springs, wonderful vistas of the town were always available as the line circled around the southern slopes of the foothills, then crossed a metal viaduct bridge over Ruxton Avenue before continuing around Pilot's Knob and up Ute Pass.

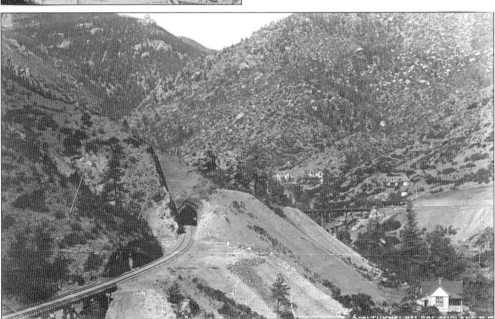

In this picture, tunnel #2 and a portion of the iron viaduct over Ruxton creek can be seen. On the other side of the canyon was another, smaller depot for the Iron Springs. The railroad had to build multiple tunnels to wind its way around the town and through Ute Pass, making it one of the most expensive sections on the whole line to build. (Courtesy Historic Manitou, Inc.)

This spectacular wreck took place on September 10, 1909 and, though no one was seriously hurt, it could have been tragic. A borrowed engine, heading east, spread the rails on the Midland viaduct, letting three cars slip off the bridge and into the adjacent photography studio. Customers in the building barely escaped before the train came through the roof. The tender is just visible on the right of the viaduct. If it had fallen, a fire could have started. (Courtesy Dick Goudie.)

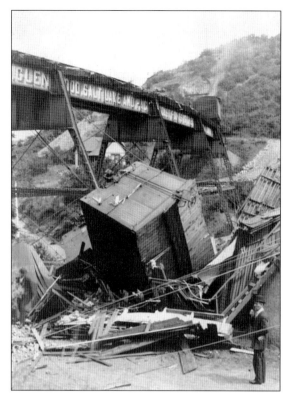

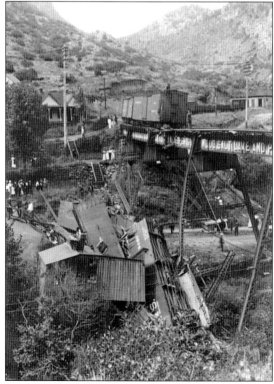

This view from the opposite side of the canyon shows the damage to the viaduct. The Manitou Casino Trolley had just passed under the span, barely avoiding disaster. The boarded up Iron Springs Depot can be seen on the right, above the tracks. (Courtesy Dick Goudie.)

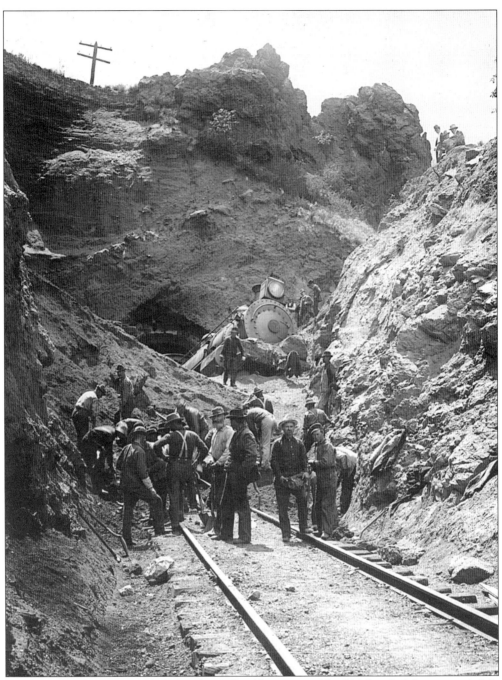

On the night of May 21, 1905, Colorado Midland locomotive No. 204 derailed due to a rockslide on the east side of tunnel #2, just above southwestern Manitou Springs. The crewmen were lucky to only be slightly injured, as the pilot house on the engine was smashed. The majority of serious accidents occurred in the Ute Pass/Manitou Springs section of the line. Often the engineers were going too fast coming down the Pass to navigate the many curves and tunnels. However, it kept the local photographers stocked with popular train wreck images. (Courtesy Historic Manitou, Inc.)

Though talk of a trolley line from Colorado Springs to Manitou Springs had started in the 1870s, Winfield Scott Stratton was the first to achieve real success with his Colorado Springs and Interurban Railway. Almost immediately the system severely curtailed business for the Denver & Rio Grande spur. Stratton built a station with a loop on Manitou Avenue just before the Ruxton intersection, where the cars could turn around.

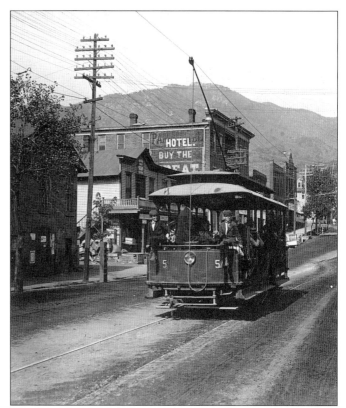

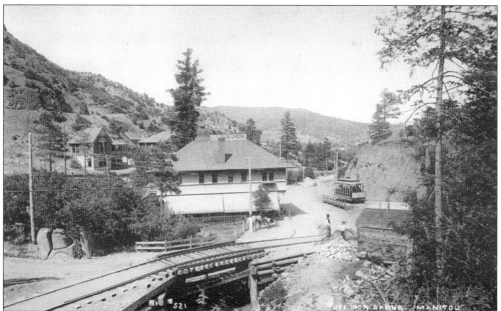

The other trolley in Manitou Springs was built to transport passengers from the main line's loop to the casino built next to the Cog Railway Depot. Affectionately named the "Dinky" by locals, the Manitou Electric Railway and Casino Company only lasted from 1895 to 1925. One of the cars is seen on the right, winding its way past the Ute Iron Pavilion.

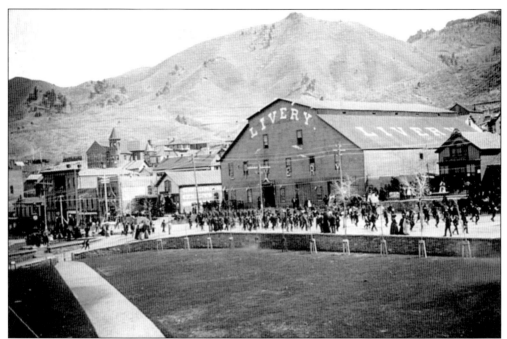

Manitou Springs was served by many forms of transportation, but the most enduring and popular was the back of a burro. For such a small town, Manitou Springs had hundreds of burros and a great many liveries, including the El Paso, seen here all decked out in bunting for a patriotic parade. Known as the "Big Barn," it burned in a spectacular fire in the early 1900s.

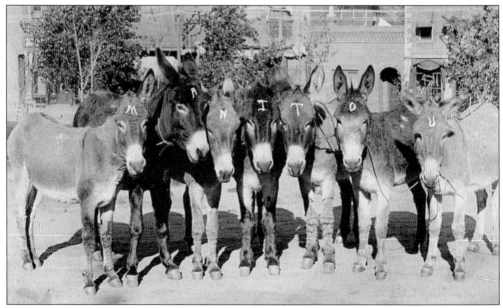

Burros were considered a staple of the photographic trade and no one could resist taking home a picture of the "Rocky Mountain Canary." However, those cute little critters were notoriously stubborn, making this image a tour de force in burro management. The cameraman did play it safe by painting on the letters for Manitou in his studio. (Courtesy Historic Manitou, Inc.)

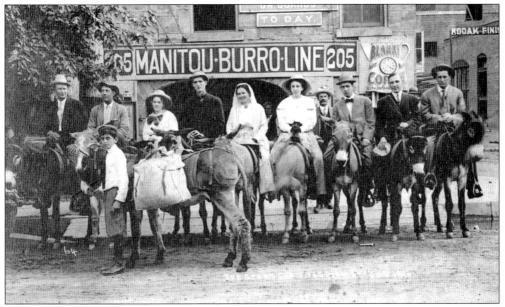

The Manitou Burro Line specialized in pack trips to the top of Pikes Peak which included a commemorative photo of the event. Burros were considered safer and more sure-footed than mules or horses. In addition, they were cheap and plentiful thanks to their use in the mines. Unfortunately, they were also noisy and paved the streets of Manitou in manure. The big coffee pot clock on the building reads "Blanke Coffee—Best on Earth or Anywhere Else." (Courtesy Historic Manitou, Inc.)

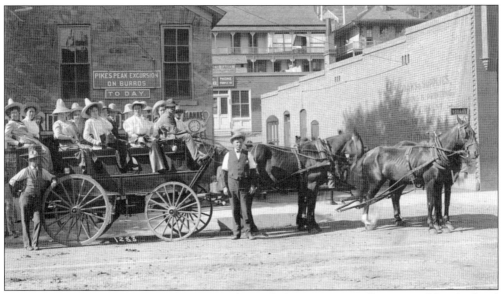

A more social form of transportation was the Tally-ho wagon, usually arranged by the local hotels and sanitariums. A picnic lunch was included with a trip up Ute Pass or the Garden of the Gods.

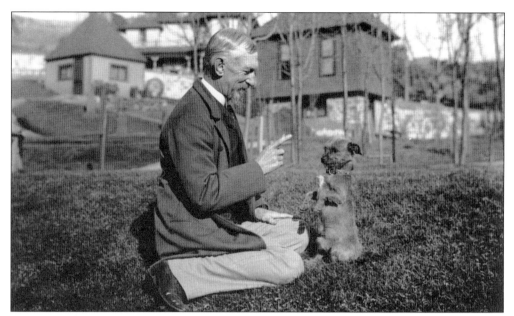

Burro trains up Pikes Peak were all well and good, but the trip was long, sometimes wet, and always hard on the backside. A cog railway had been running up Mt. Washington in New Hampshire since 1869 and Maj. John Hulbert, Manitou Springs entrepreneur extraordinaire and sometime dog trainer, began to promote a similar idea for Pikes Peak. (Courtesy Colorado Springs Pioneers Museum.)

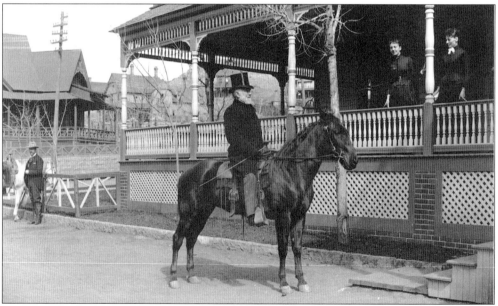

Major Hulbert's idea of a cog railway was made possible by the considerable investments of Zalmon Simmons, the inventor and manufacturer of the inner spring mattress. Simmons put money in the scheme because he had been vacationing in Manitou Springs for at least ten years and saw the potential for a major profit, but his involvement is traditionally attributed to an uncomfortable ride to the summit on an uncooperative burro. (Courtesy Colorado Springs Pioneers Museum.)

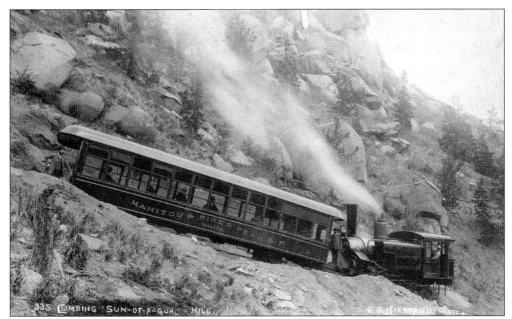

The Manitou and Pikes Peak Cog Railway first began to lay tracks in 1889. Most of the workmen were Italian immigrants, some of whom were killed by rock slides or shrapnel created by the blasting. This view of the train is at Son of a Gun Hill and shows the 25% grades that had to be overcome. (Courtesy Historic Manitou, Inc.)

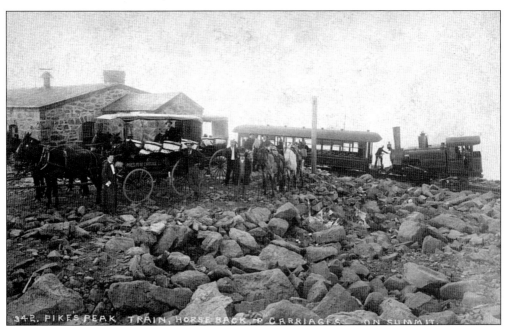

The rails were laid by 1890, but the first passenger train didn't make it up the slopes of Pikes Peak until June 30, 1891. This early view of the train and summit house also includes one of Manitou Springs' prime motivations for developing the cog. The Pikes Peak Carriage line, whose horse-drawn coaches are seen here, had completed a tourist road up the peak in 1888 and it originated from Cascade rather than Manitou Springs. (Courtesy Historic Manitou, Inc.)

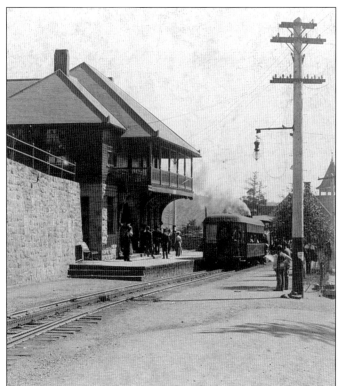

The lower depot of the cog railway was constructed of stone and wood with a European flare by master builders Archie and Angus Gillis in 1890. To the far right can be seen the Iron Springs Casino, which was later moved across Ruxton Avenue to become the third Iron Springs Hotel. (Courtesy Historic Manitou, Inc.)

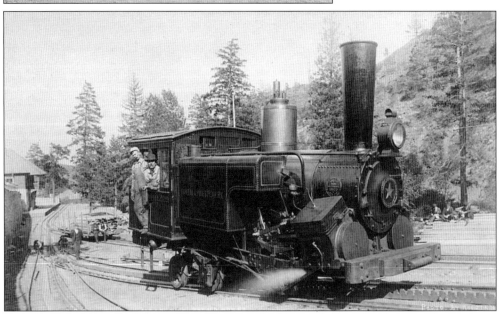

Due to safety concerns, the cog engine was designed to push the passenger cars up the slopes of Pikes Peak. If the engine somehow failed, the passenger car had its own braking system to prevent runaway accidents. The difficult terrain precluded passing tracks, so every morning these workhorses would drive their load of tourists up the steep slopes, one after the other. (Courtesy Historic Manitou, Inc.)

The great enemy of a profitable season on the cog railway was snow. Tourists were quite impressed with the huge, icy banks they passed on the upper slopes in late spring. Railway workers who had to shovel the snow were less impressed. The railway owners knew that a belated spring snow or one in early fall could shorten the amount of time the cog could run. (Courtesy Historic Manitou, Inc.)

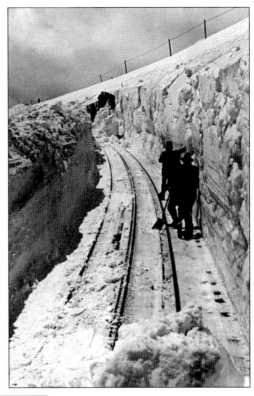

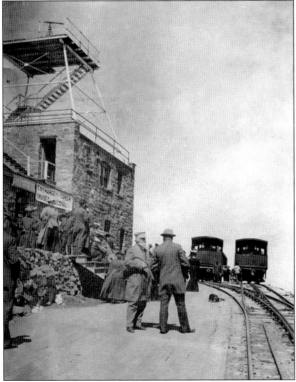

An observation tower was added to the old weather observatory summit house, since, even at a height of 14,110 feet above sea level, some people wanted to be even higher. Telegrams and post cards could be sent from the station, but group photographs were usually taken on the trip up so they could be developed as soon as possible for the returning passengers. (Courtesy Historic Manitou, Inc.)

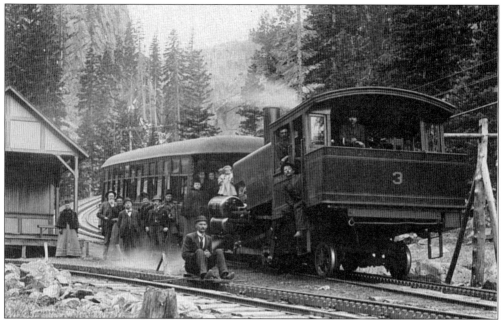

Cog engine #3 is shown stopping at the Halfway House siding. The owners of that hostelry ran a small post office, so that visitors' letters could be postmarked from Pikes Peak. The man posing on the rails is riding a Pikes Peak toboggan, a dubious contraption that enabled railway workers, with the aid of a balancing pole, to speed down the tracks to the lower station rather than wait for a train. Most of them made it. (Courtesy Historic Manitou, Inc.)

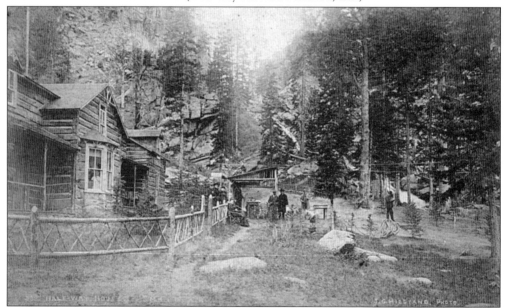

The Halfway House was started by the Palsgrove family in about 1885 as a small log cabin where visitors to Pikes Peak could stop for refreshments or spend the night if they couldn't make the climb in one day. The arrival of the cog railway brought a lot more people past their front door and the cabin was greatly enlarged to keep up with the demand. (Courtesy Historic Manitou, Inc.)

One citizen who was unhappy with the arrival of the cog railway was William E. Hook. He had built a quiet, idyllic home for himself and his family on the slopes of Pikes Peak in a spot he called Artist's Glen. The Palsgrove brothers had helped him complete the home in 1886 and he brought his family from England the following year. The cog line literally went right past his front door, as seen in this view.

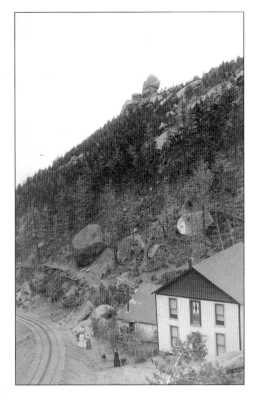

William Hook had originally come to Manitou Springs in 1885 to work for local photographer Mrs. Galbreaith, but soon set out on his own. Though he had to take a lot of "tourist on burro" pictures to earn a living, he also captured the beauty of the region in some wonderful, artistic images. He is seen here on the Pikes Peak Trail with favorite burro Marshal von Blücher carrying his glass plates and camera. (Courtesy Historic Manitou, Inc.)

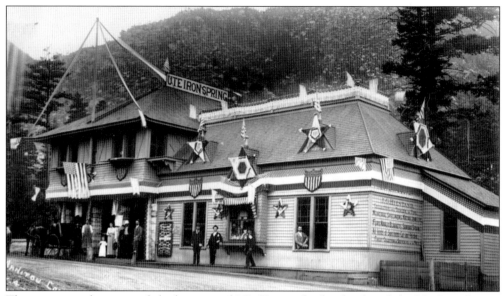

The cog certainly improved the business of J.G. Hiestand, who developed the Ute Iron Spring into a multi-story tourist Mecca, equipped with a photography studio on the upper floor and a mineral water and lemonade stand plus dance floor on the lower. Here the building is all decked out for the Fourth of July. Special window extensions seen on the second floor were for exposing glass negatives.

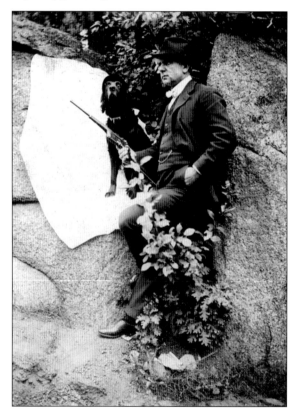

Joseph G. Hiestand was a New Yorker who came to Manitou Springs in the 1870s to run a museum, which was actually a rock and specimen store. He loved hunting and taxidermy and personally stuffed the last buffalo shot on the Front Range. Unfortunately he accidentally shot himself in 1916 while cleaning his rifle, an act so unbelievable to his friends that a rumor spread of foul play. (Courtesy George White.)

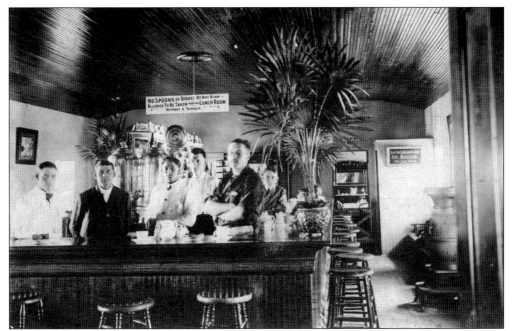

Hiestand did a very good business selling Manitou lemonade. The effervescence and the minerals in the spring water impart a very pleasant flavor when combined with citrus. It is still a popular local concoction. The sign above the servers' heads reads "No Spoons or Dishes of any Kind Allowed to be taken from this Lunch Room without a Deposit."

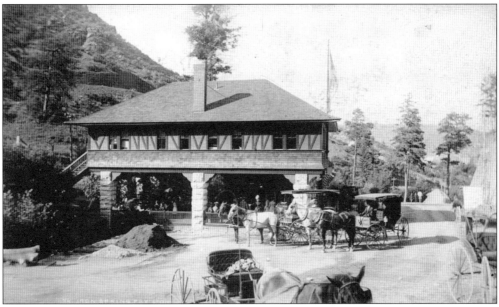

In addition to all his other talents, Hiestand was also an excellent photographer. He was given the sole concession for image taking for the cog railway and was known to have used a Pikes Peak toboggan to speed back to his studio, seen on the second floor, so the pictures could be ready for the returning passengers. (Courtesy Historic Manitou, Inc.)

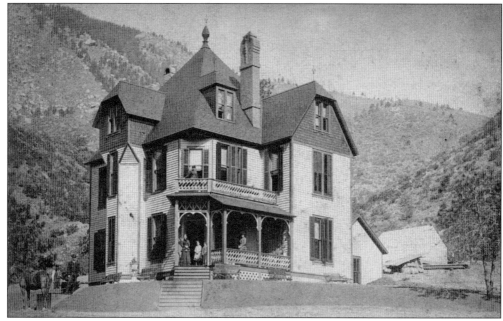

In 1884 a Michigan partnership known as the Iron Springs Company began to develop the area above the Ute Iron Spring with a number of cottages. This one was known as the Iron Spring House and probably functioned more as a boarding house than a rental cottage. (Courtesy Historic Manitou, Inc.)

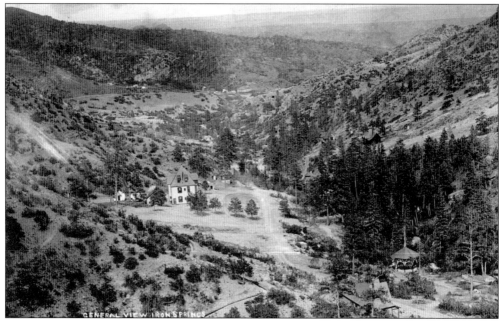

This elevated view shows the location of the Iron Spring House with Manitou Springs spread out in the widening valley below. It also indicates the distance between the town and the popular Iron Springs. The Ute Iron can be seen at the left edge of the dark clump of trees and the Little Chief is at the bottom of the same trees. (Courtesy Historic Manitou, Inc.)

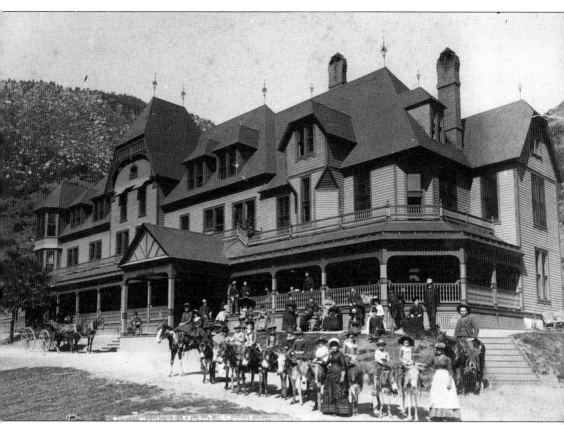

After only one year, the Iron Springs Company decided to greatly expand the Iron Springs House into a true hotel. No expense was spared to make this the most state of the art, luxurious inn in Manitou Springs. The company installed a small power plant, making this the first electrified building in town, thus allowing for the use of steam heat to truly extend the season throughout the winter. The city of Manitou Springs was busy electrifying the streets at the same time, so the summer evenings of 1885 saw the glow of electric arc lights reflecting off the surrounding hillsides. (Courtesy Historic Manitou, Inc.)

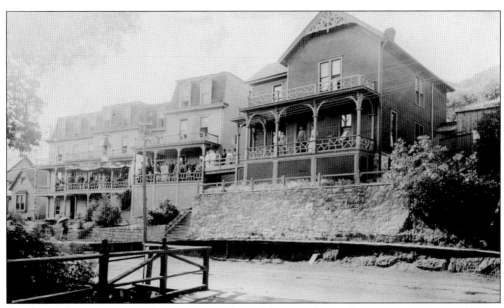

As the 19th century was drawing to a close, Manitou Springs' prospects were reaching a crescendo and the need for more summer housing never ceased. The Brookside, a boarding house from the 1880s, was soon flanked by the much larger Ruxton House, which became a very popular, moderately priced hotel, though it had a propensity to catch on fire when the mortgage was due.

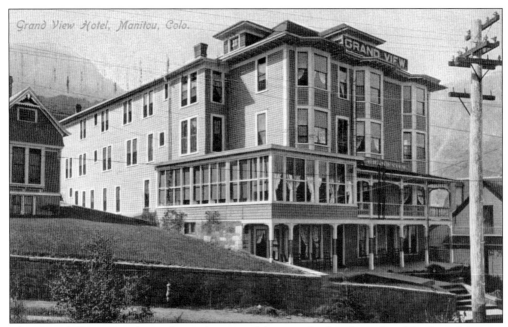

The Grand View, seen here after a few remodels, was the last large hotel built in Manitou Springs, in a previously residential neighborhood above and to the southwest of the Barker. William Paulson, a German immigrant, spent $6,000 in 1891 for the original structure, then acquired the hotelman's disease of "addition addiction" for many years after that. (Courtesy Historic Manitou, Inc.)

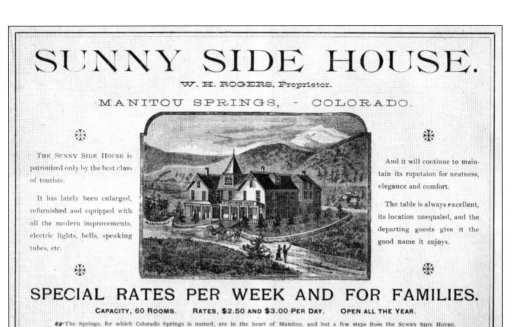

As new hotels sprang up, old ones needed to keep pace. This early 1890s ad for the Sunnyside House refers to "modern improvements, electric lights, bells, speaking tubes," as well as a three-fold enlargement of the facility. Captain Rogers may have caught the "addiction," but he maintained his old-fashioned hospitality. (Courtesy Historic Manitou, Inc.)

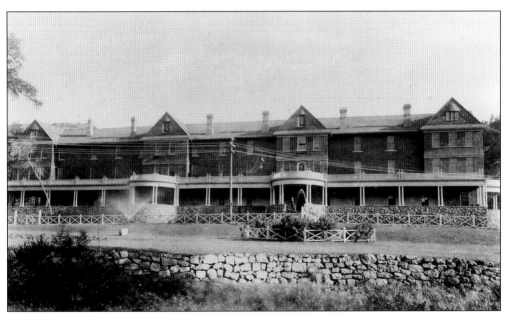

Popularity was fleeting in the hotel business. The Manitou House, the first among many, had quickly lost its reputation as the place to stay. By the 1890s it was the place not to stay, so a major overhaul was accomplished in the Colonial Revival style popular at the time. Unfortunately the Manitou House's face lift only lasted until a 1903 fire. (Courtesy Colorado Springs Pioneers Museum.)

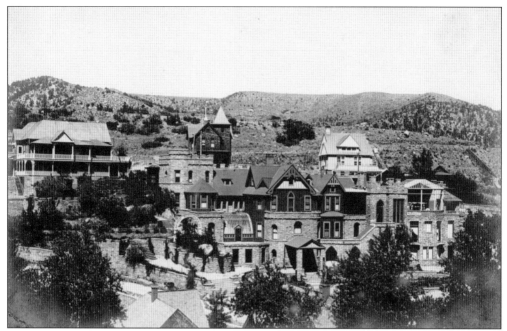

Though Manitou Springs was considered a health resort, there weren't many sanitariums. Perhaps the city fathers wanted the sick but not the desperately ill. One exception was Montcalme, seen here in the upper left. Built by Father Francolon, a French Priest with some family money, it was given to the Sisters of Mercy for a hospital while the Father moved on to build Miramont, the larger structure in front. (Courtesy Historic Manitou, Inc.)

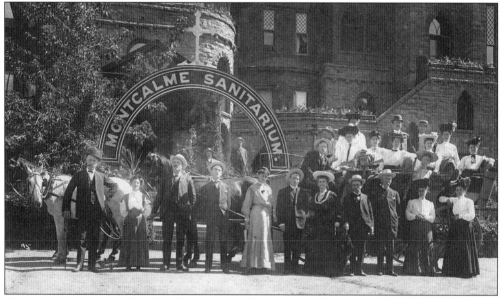

Based on the many styles of architecture he had witnessed as the child of an ambassador, Father Francolon's second home was only lived in for three years, when he sold it to the Sisters. Miramont soon became the second Montcalme Sanitarium when the original burned down. In this view some of the residents are about to take a Tally-ho ride. (Courtesy Historic Manitou, Inc.)

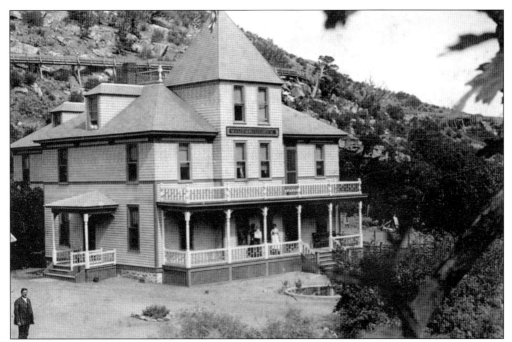

This structure went up in 1887 for $7,000 and was named the Manitou Sanitarium. Dr. Lewis built and ran it for a few years at which point the name was changed to the Mineral Springs Hotel. Located on the western end of Manitou Avenue, near to the Ute Chief Spring, it succumbed to fire in 1895.

Since the beginning, tents remained a popular choice for health seekers and vacationers. However, even these temporary residences were becoming more sophisticated. Many Manitou Springs residents built and rented tent houses, which were a house frame with a roof, walls up to waist height, and awning fabric taking the place of expensive windows. Though meant to only last a short time, some tent houses were eventually converted to all-season dwellings. (Courtesy Carol Davis Warner.)

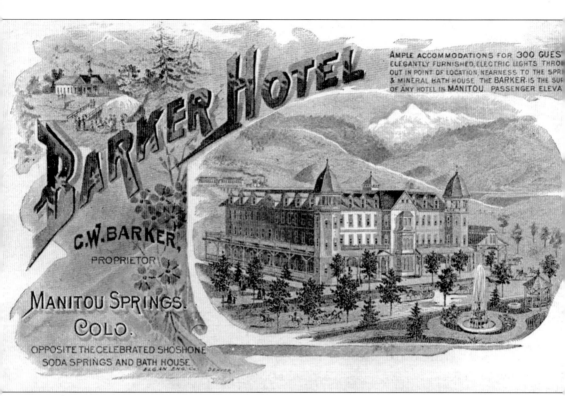

Charles Barker was a prime example of how "addition addiction" could get out of hand. He bought Pine Cottage and enlarged it several times after 1881. By the printing of this business card in about 1890, Barker had spent well over $20,000 expanding his hotel into one of the best in the state. The Barker House was the first to have a hydraulic elevator in Manitou Springs and was well known for the excellent quality of food and service. Unfortunately, Barker was forced to sell the establishment in 1897 due to overextended resources and it was renamed The Navajo in 1905. (Courtesy Historic Manitou, Inc.)

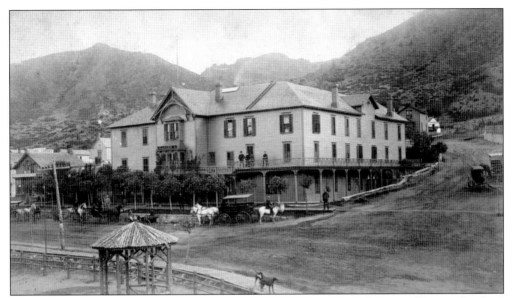

This image of the Barker House must have been taken in 1885, as that was the year the third story was added and the last year the Seaside Library was in operation. It wasn't actually a lending library but a book and stationary store run by the widow of James Thurlow in his original studio. The sign is visible on top of the building to the left of the hotel. The original Catholic Church can be seen between the two structures.

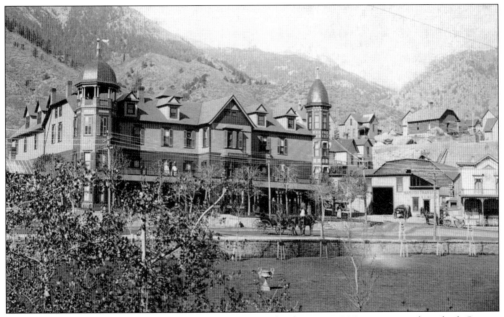

The final transformation of the Barker House took place in 1890, creating the ideal Queen Anne-style building with the addition of the symmetrical but disparate towers. Charles Barker lost the hotel in 1897 but stayed on as manager until his death in 1905. His monumental undertaking was altered little in the intervening years and was restored in the 1980s.

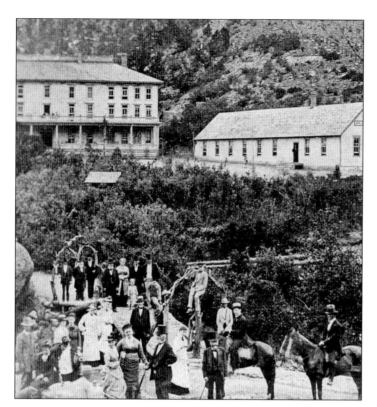

The original owners of the Cliff House were so confident of success that, in their second season, they built a three-story, nine room addition, and a separate wing with a bowling alley and billiard hall. The bowling alley was popular with the ladies, as it didn't serve alcohol, but the hotel improvements didn't save Schurtleff and Webster from a surprising bankruptcy by 1875. (Courtesy Historic Manitou, Inc.)

In 1876 Edward Erastus Nichols leased the Cliff House and immediately began creating a reputation for excellence that would last for the next 60 years. By 1885, when this view was taken, he had bought the building and changed the billiard hall into a two-story room addition. Visible in the foreground is the new Soda Spring pavilion, under construction, and the rustic gazebo, now moved to the Navajo Spring. (Courtesy Historic Manitou, Inc.)

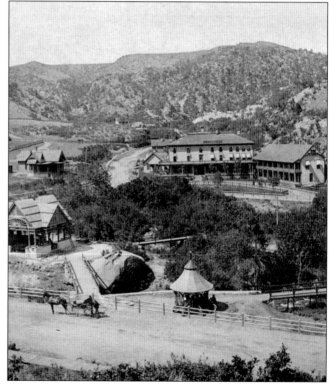

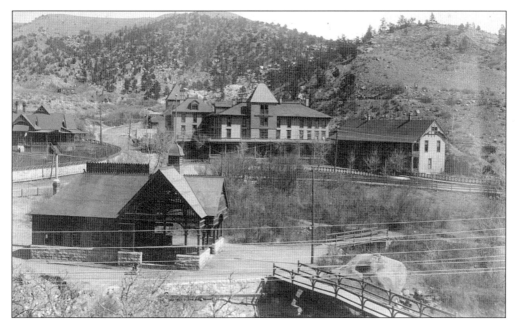

Between 1887 and 1888 Nichols enlarged the Cliff House hotel again with a three-story addition to the north and two square towers. The new wing was built to house guests only in the summer. Despite constant advertising, tourists could never be enticed to visit in the winter. Consequently the Nichols family bought the Hotel Florence in California and closed the Cliff House in the off season. (Courtesy Historic Manitou, Inc.)

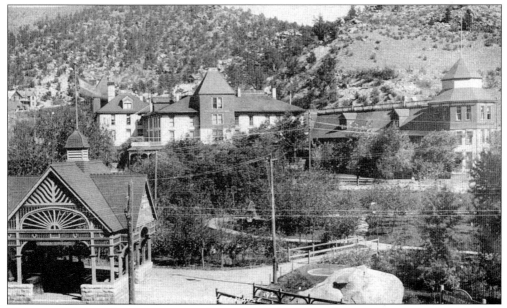

The year 1889 saw the construction of an octagonal tower and improvements to the east wing of the Cliff House for a princely sum of $10,000. Ironically, that was the portion of the building that burned a few years later—the only severe fire in the Cliff House's history until a disastrous conflagration in the 1980s. (Courtesy Historic Manitou, Inc.)

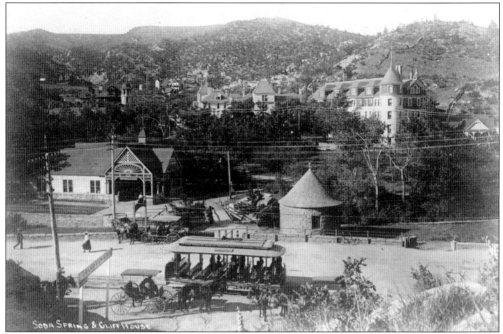

By 1900 the east wing was reborn as a four story, stone edifice of elegant design and the oldest portions of the building were soon restyled to match. Like the town around it, the Cliff House had aged to a charming state, which would last until the present day. (Courtesy Historic Manitou, Inc.)

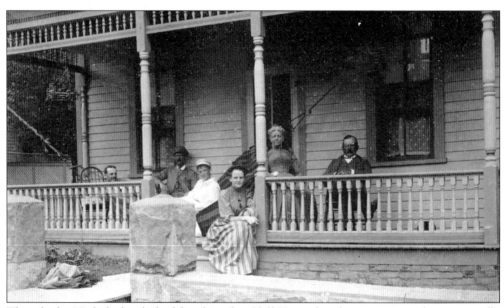

Though the Nichols family had lived in the Cliff House hotel at one time, they eventually moved into this cozy cottage on the northern part of their property. The four children sitting on the porch, from left to right, are Edward E. Jr., William, Ida, and Anne, with the parents Anne and Edward Sr. to the right. Each of the Nichols children had a hand in running the family business, though Ida and E.E. Jr. made it a career. (Courtesy Ed and Meg Nichols.)

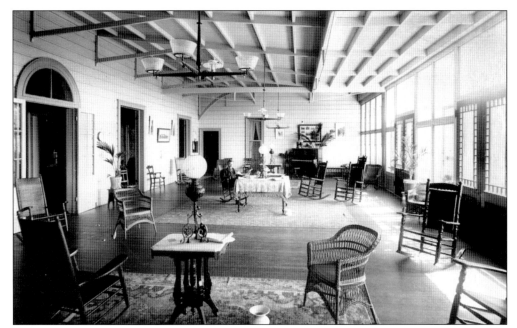

This image shows the northern wing's sunroom aglow in afternoon light. Its comfortable furnishings and restful atmosphere were appreciated by guests who returned year after year. One special visitor was Thomas Edison, who, being a relative by marriage to William Nichols, brought his old friends Firestone and Ford here on one of their yearly retreats.

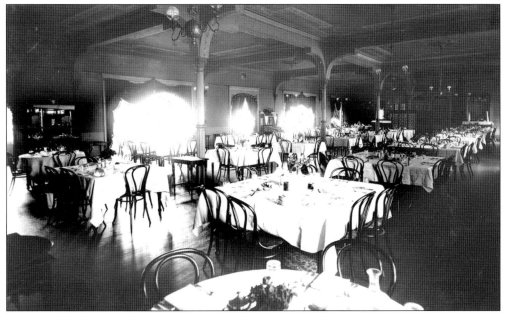

The dining room of the Cliff House was representative of the family and the business: practical, pleasant, first quality, and always in good taste. Guests with families were especially fond of the Ordinary; a separate dining facility for children, nannies, and other servants. Young ones were always kept well entertained by the staff and by Miss Ida, who staged fancy dress parties and minor theatricals starring the smallest guests.

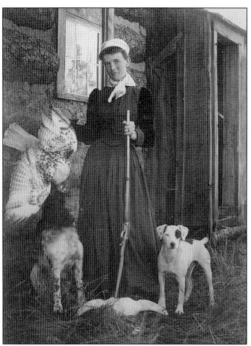

Growing up female in the west meant you had to shoot straight and still dress like a lady. Here Ida Nichols poses with her trophy hawk, rifle, and the family terrier Nip. This tough little dog took a liking to train travel and would catch rides on the Colorado Midland to points unknown. (Courtesy Ed and Meg Nichols.)

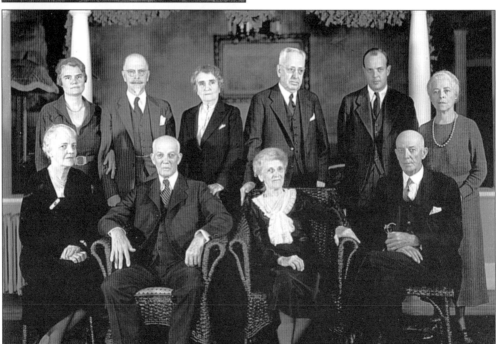

When the senior Nichols passed on, E.E. Jr. took over with as much competence as his father. Thanks to his hard work the Cliff House remained a place the far flung family could return to, as seen in this reunion photo. Pictured from left to right are: (sitting) Anne, William, Ida, and Edward E. Jr.; (standing) Marion (daughter of William), her husband Albert de Marconnay, her mother Mary (wife of William), Harry Holt (husband of Ida), Proctor (son of E.E. Jr.), and Lilie (second wife of E.E. Jr.) (Courtesy Ed and Meg Nichols.)

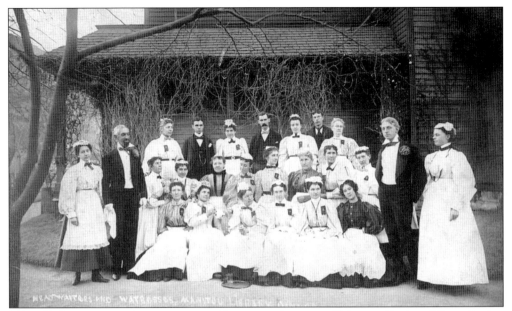

Major Hulbert was another important influence on the town of Manitou Springs. His profession in the directory was listed as entrepreneur and he invested heavily in the cog railway, the bottling plant, and the bath house. This is a picture of some of Manitou Springs' finest, serving as wait staff for the library fundraising dinner, standing outside Hulbert's home, Agate Hill. The major is standing second from the left. (Courtesy Jean Garrity.)

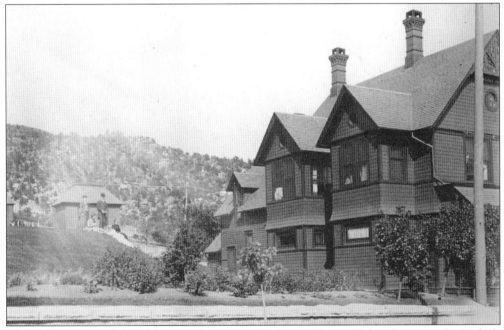

The Hulberts moved from Manitou Springs in the 1890s. They sold their home to the Nichols family who renamed it Hillcrest. The house stood on Grand Avenue for many years until it was radically altered in the mid 20th century. The Major and his family can be seen standing next to the garden structures that remain in the yard today. (Courtesy Ed and Meg Nichols.)

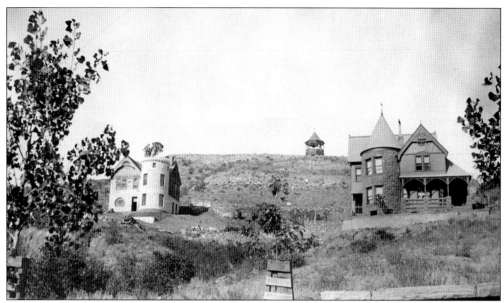

Grand Avenue was certainly the fashionable street. William A. Davis, who owned the concession stand in the Manitou Soda Pavilion, preferred it so much that he built two houses there. The one on the right was the first, built in red sandstone for his first wife. The one on the left used white sandstone and was for his second wife. Inevitably, tensions ensued between the two households.

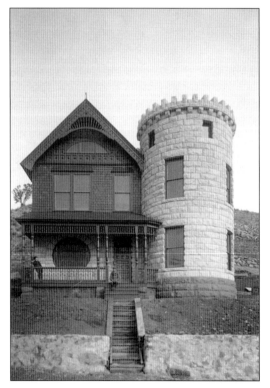

Davis' second home, known as White Tower, was a quintessential Queen Anne style Victorian house, but locals started calling it a castle for obvious reasons. This tradition has passed to the present day, with all of Davis' buildings being titled castles. Another old Manitou-ism refers to the many rock retaining walls, like the one seen here, as "stone fences."

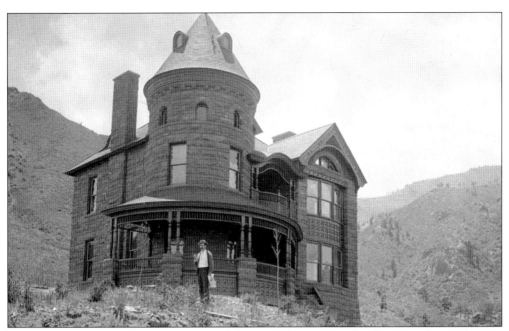

W.A. Davis and his brother R.M. Davis did seem to be enamored with turreted stone houses, since they wanted to build a whole subdivision of them on the slopes of Iron Mountain. They did manage to construct one, known as Redstone Castle, but its isolated location and expense put potential investors off.

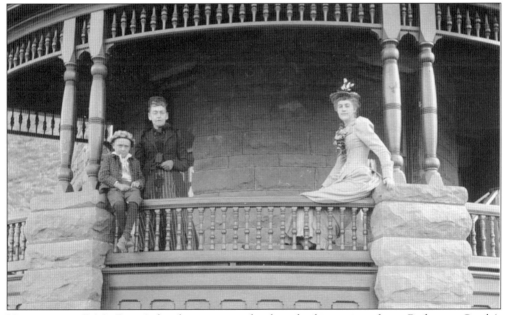

Here we see R.M. Davis' family enjoying the breathtaking view from Redstone Castle's wraparound porch. The home has had many interesting residents, but none as notorious as Alice Crawford, who was said to hold séances here. Falling on hard times, Alice attempted suicide but only succeeded in shooting herself in the knee. After extensive newspaper coverage of the event, Alice felt obliged to leave town.

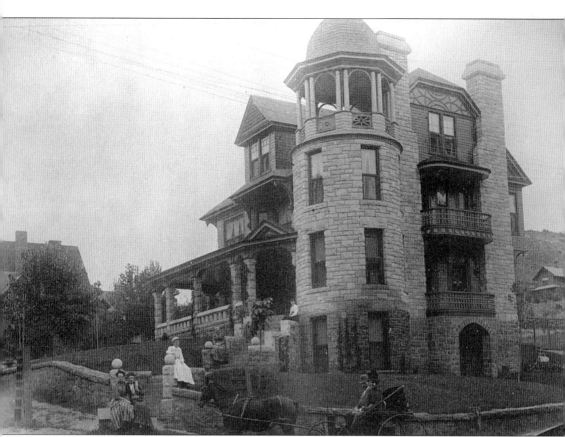

The wonderful home at the corner of Grand and Cañon Avenues, across the street from the Cliff House, is today known as the Nolon House, but it was originally built for J.E. Newton, a Colorado Springs Lumber Dealer. Finished in 1890, the unique structure was bought 10 years later by Johnny Nolon, who made a small fortune in the saloon trade in Manitou Springs, then went on to make a larger one in the boom town of Cripple Creek. One of his bars was called the Buffalo Saloon for the sandstone namesake standing out front. In later years, the stony bison was moved to the side yard of this house, where the neighborhood children used to love climbing it. The sculpture eventually eroded, due to the softness of the local stone. (Courtesy Ed and Meg Nichols.)

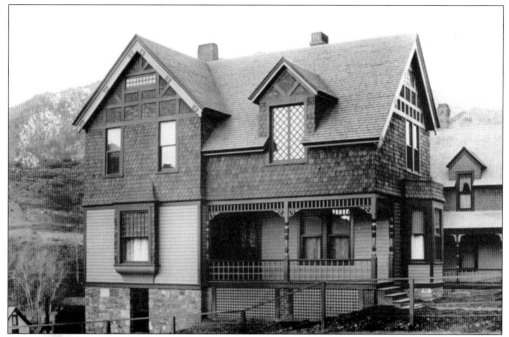

This fine cottage was also located on Grand Avenue and built by Mr. Glasser, the manager of the local bank, in 1889 for $3,500. By the mid-1890s it was owned by a Mrs. Stehr, whose son Frederick also worked at the bank for a time. (Courtesy Colorado Springs Pioneers Museum.)

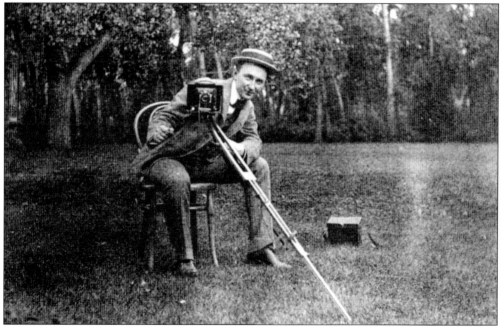

Frederick Stehr took an active interest in photography, as is obvious in this image. Though an amateur, he had an amazing talent and recorded the lives and homes of his neighbors in a wonderful collection of glass plate negatives that have eventually made their way back to Colorado Springs. (Courtesy Colorado Springs Pioneers Museum.)

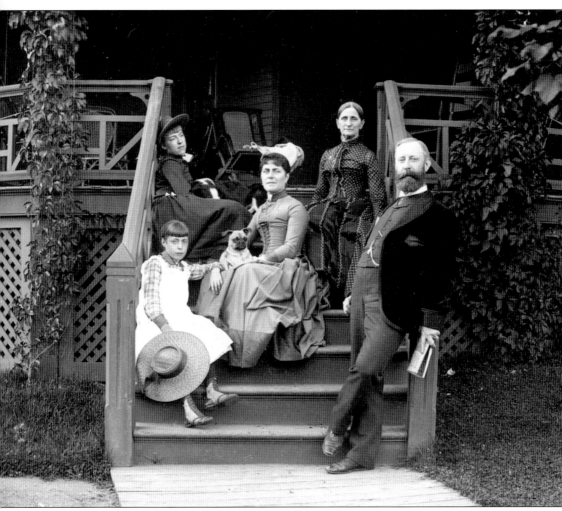

Frederick Stehr's most important neighbor and one of Manitou Springs' greatest benefactors was Jerome B. Wheeler, seen here with his wife Harriet and their two daughters, Elsie and Marion. The older woman is unknown. The family is relaxing on the front steps of their home Windemere. Wheeler is remembered for his huge investments in Aspen, Colorado, but his wife preferred to live in gentility at Manitou Springs. Harriet's uncle was Roland Macy, founder of the famous department store and the source of her husband's good fortune, since he was co-manager of the business for many years after Mr. Macy's death. (Courtesy Colorado Springs Pioneers Museum.)

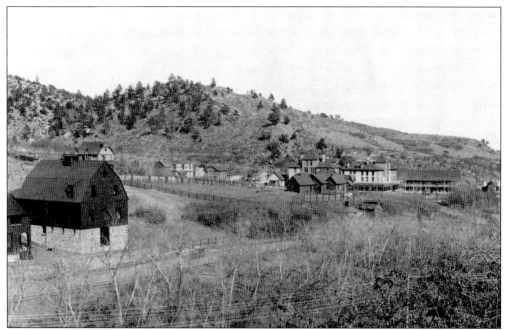

This view from western Park Avenue illustrates the extent of the Wheeler estate. On the left is the stone barn and cottage, executed in fine eastern style in 1888. The intervening space between these structures and Windemere, which stands in front of the Cliff House, was soon to be filled in with some of Manitou Springs' finest buildings. (Courtesy Historic Manitou, Inc.)

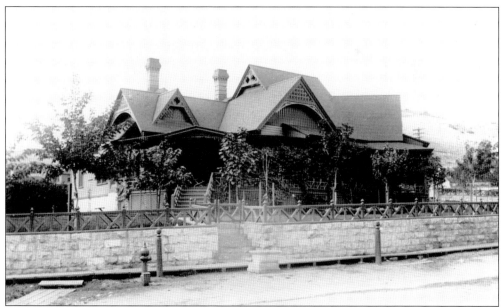

The Wheeler family came to Manitou Springs in 1885 to relieve Harriet's health problems, buying the Pomeroy Cottage and spending $5,000 to renovate it into this sophisticated summer home. The site is where the present-day Post Office is located and the stone wall seen here still exists. Windemere was torn down in the 1920s to make room for a hotel and theme park that never materialized. (Courtesy Colorado Springs Pioneers Museum.)

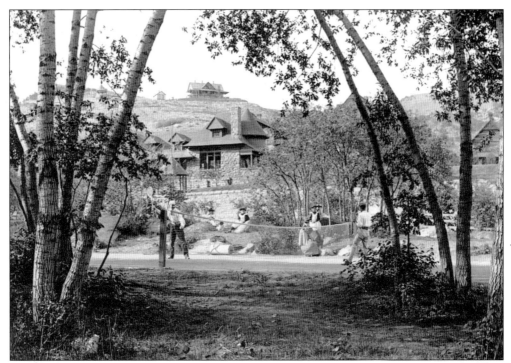

This Stehr photograph shows the idyllic lifestyle available to those like the Wheeler family. The structure in the background is Windemere's Bowling Alley, built at a cost of $12,000 in 1891. Of the entire grand estate, this building and the barn are the only remnants left today. (Courtesy Colorado Springs Pioneers Museum.)

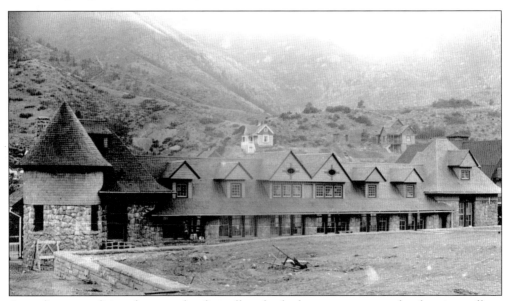

According to tradition the stone bowling alley also had guest quarters and a shooting gallery. What they shot is unknown. These images were probably taken soon after construction, as a beautifully landscaped garden filled this blank area at a later date. (Courtesy Colorado Springs Pioneers Museum.)

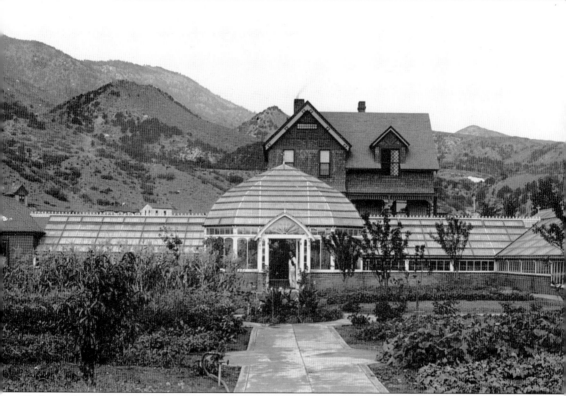

Perhaps the crowning glory of the Windemere estate was the complex of greenhouses that abutted Grand Avenue on the south side. Built the same year as the bowling alley, they cost a staggering $15,000. When you add up what Jerome Wheeler spent on this property plus his other investments and local contributions, the figure comes to well over a hundred thousand in 1890s dollars. In 1893 Wheeler was rumored to be planning a new house here, built of marble from his quarries in Yule, Colorado. That same year silver was demonetized and many fortunes in the state collapsed overnight. Wheeler would not be completely destitute, but dreams of marble palaces were never to be again. (Courtesy Colorado Springs Pioneers Museum.)

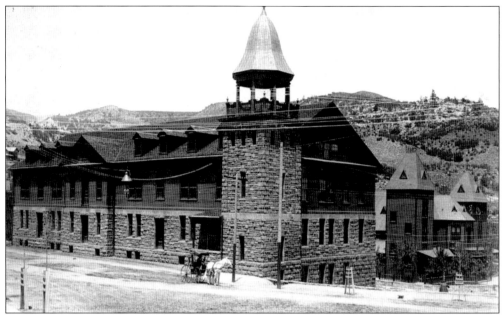

Wheeler's major contribution to Manitou was the organization of the Manitou Mineral Water Bottling Company and the construction of its $35,000 bottling facility seen here. The company also owned the bath house, seen to the right, and Soda Springs Park up to the Navajo Spring. The grounds were beautified for the benefit of the community.

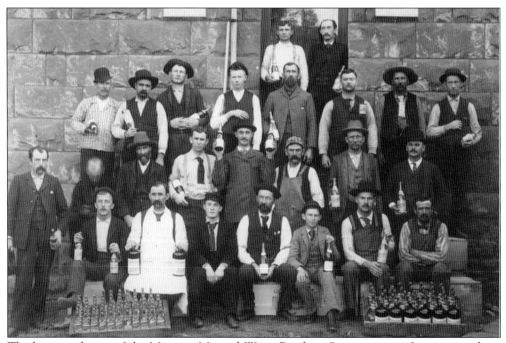

The busy employees of the Manitou Mineral Water Bottling Company pose for picture taking on the north side of the plant. Some of the men are holding bottles of the product with great reverence and one has his upside down in his pocket. Some things never change. (Courtesy Manitou Springs Volunteer Fire Department.)

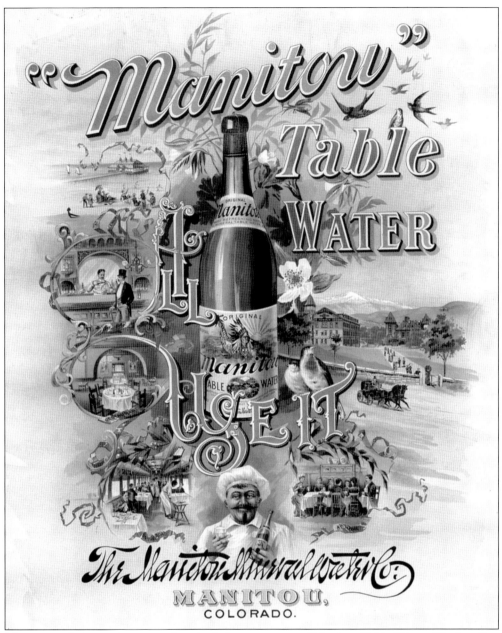

This ornate lithograph poster advertised the many uses of Manitou Table Water. The bottling plant, bath house, and landscaped grounds can be seen on the right side of the bottle. These posters were part of a well-organized and funded campaign to export Manitou Springs' liquid treasure to all parts of the United States. This water was unique because it was recharged with its own carbonic acid gas (carbon dioxide) after sterilization and had a greater amount of suspended minerals than any other competitor. Success was evidenced in the 100,000 bottles shipped in one sensational month in 1891. Profits were impressive and many of Manitou Springs' young men were employed at the plant. Wheeler had also built a glass factory in Old Colorado City to keep the cost of bottles to a minimum. The good times came to an end in 1893, though the plant would continue to run into the next century. (Courtesy Historic Manitou, Inc.)

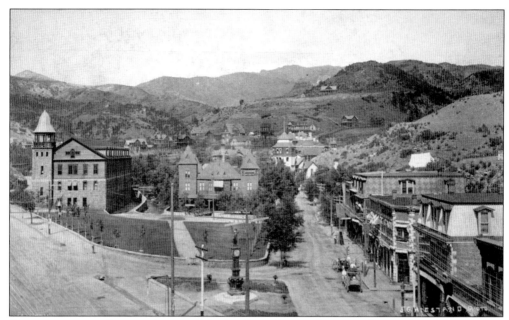

To commemorate the completion of the bottling plant and surrounding park in 1891, Jerome and Harriet Wheeler donated the water fountain and town clock, seen in the center of this overview of downtown Manitou Springs. Humans could drink from the stylized dolphin heads, while dogs had their own bowls at the base. (Courtesy Historic Manitou, Inc.)

WHEELER FOUNTAIN.

This woodcut of the Wheeler Fountain clearly shows the elegant statue of Hygeia, the Greek goddess of good health, daughter of the god of medicine and goddess of soothing. She was the perfect choice to watch over Manitou Springs. This grand sculpture was restored in 1991 and still keeps time today. (Courtesy Historic Manitou, Inc.)

The second Manitou Bath House was developed by Major Hulbert and General Adams, with construction completed in 1883. The facility was an immediate success, partly because the old bath house was dilapidated and partly because the finest hotels only had one bathing room per floor. Wheeler included this property in his grand scheme for downtown Manitou Springs. (Courtesy Historic Manitou, Inc.)

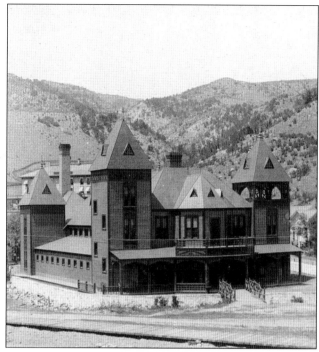

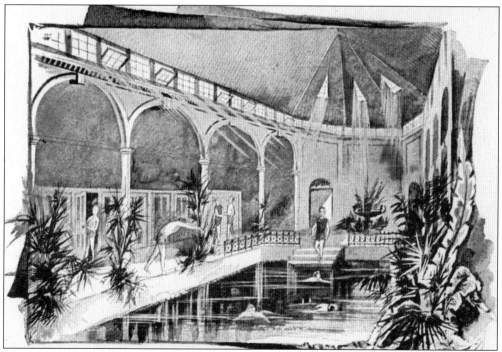

This illustration of the interior of the bath house shows the Plunge Pool at the center of the building. The sexes had separate hours for immersions and women were encouraged to wear their corsets under their bathing smocks. Surrounding the pool were private rooms with tubs of heated or chilled mineral water, depending on the need of patients. Changing rooms, reading rooms, and a doctor's office took up the rest of the rooms. (Courtesy Historic Manitou, Inc.)

In the winter of 1886 fire destroyed Manitou Springs' finest mansion, the Briarhurst. The fire department, which was generously endowed by Dr. William Bell, could do nothing as the creek was frozen in the 15-below-zero temperatures. William was away at the time but Cara and the servants saved as many of their possessions as possible, plus their favorite painting. By 1888 a new Briarhurst rose to take its place as the town's social center, but the intervening years had been difficult. As the century passed into the next, the Bell family spent less time in America, though William still had many investments here that required a few months of residence each year. In 1921 Dr. William Bell passed away and his son Archie soon sold the family home in Manitou Springs. This image was taken in happier times, when Cara, William, and their daughter could relax in the conservatory of their mountain cottage by Fountain Creek. (Courtesy Colorado Springs Pioneers Museum.)

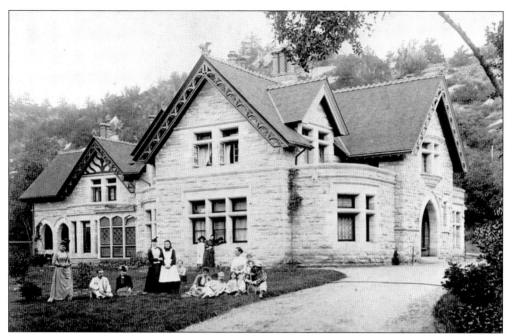

Dr. Bell took great care in the design and construction of the new Briarhurst. The Colorado peachblow granite facade suited the English, Arts and Crafts style, and he even imported British workmen to guarantee his standards were met. At $40,000 it was the finest home in Manitou once again. (Courtesy Colorado Springs Pioneers Museum.)

The library room was built with a special alcove for "The Mount of the Holy Cross" by Thomas Moran. Cara had risked her life in the fire to help cut the painting from its frame, so it was given pride of place in the new home. The painting has since left the area, but Briarhurst still remains as a legacy to Manitou Springs' past glories. (Courtesy Colorado Springs Pioneers Museum.)

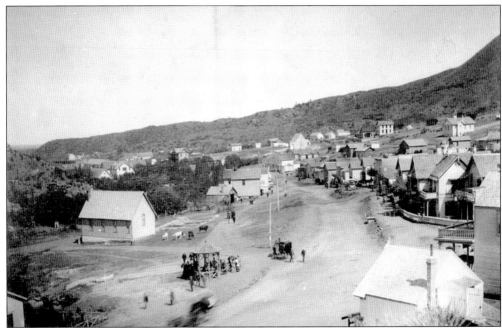

Another of the Bell family's bequests to the town of Manitou Springs was St. Andrew's Episcopal Church. Though money was raised early on, the actual structure wasn't built until 1880 on ground donated by the Bells. The simple, white frame building can be seen in this view in the left mid-ground, with the cows grazing to the right of it. (Courtesy Denver Public Library Western History Department.)

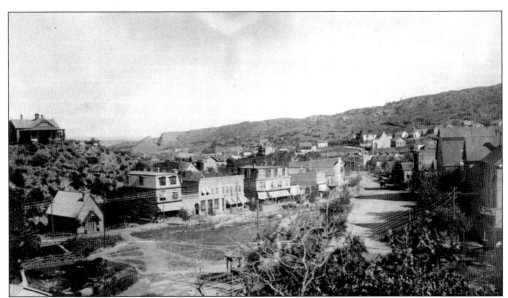

By 1885 an effort was being made to consolidate the central core of Manitou Springs into Soda Springs Park and little St. Andrew's Church was in the way. Major Hulbert donated new land and money to move the building to the other side of the street. It is shown on the far left in this image, complete with a new stylish portico. (Courtesy Denver Public Library Western History Department.)

The interior of St. Andrew's was humble, like the outside, though the cream of Manitou Springs society and visitors attended services here. The Bell girls taught Sunday school here and Cara played the organ, impressing fellow worshipers with her enthusiasm. (Courtesy Colorado Springs Pioneers Museum.)

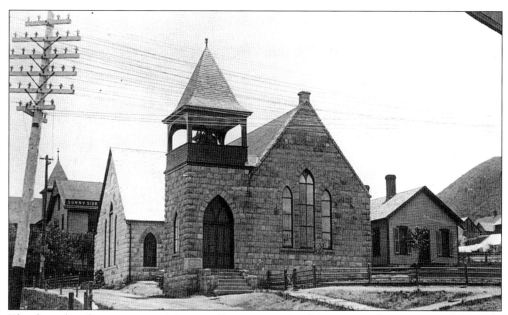

The first church structure in Manitou Springs was the Community Congregational Church, begun in 1879. By 1891 a new wing was added to accommodate the large number of summer guests. A rare and splendid 1870s tracker organ was donated by a church in Colorado Springs and still graces today's worshipers with its glorious tones. (Courtesy Manitou Springs Community Congregational Church.)

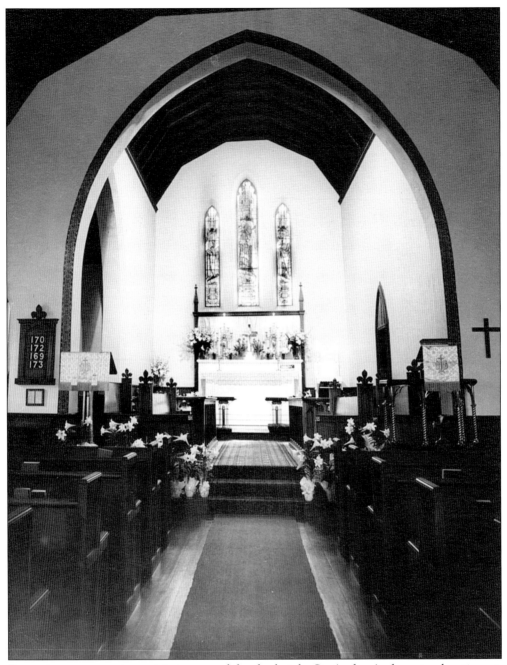

Expansion was a passion not just reserved for the hotels. St. Andrew's charming location on Fountain Creek turned out to be a mixed blessing when a 1894 flood nearly removed it from its foundations. It was then decided that the old location hadn't been so bad, and the importance of Soda Springs Park had been diminishing as pieces of it were being sold for development. In 1906 the magnificent stone edifice of the new St. Andrew's was dedicated. This view shows the nave and altar, donated by the Nichols family. The stained glass windows were commissioned from a renowned artist in England to portray Cara Bell as St. Mary and Anne Nichols Sr. as St. Anne. (Courtesy Ed and Meg Nichols.)

Considering the location of the new St. Andrew's was at the intersection of Manitou Avenue and Cañon Avenue, just west of the Wheeler Fountain, part of the building was lower than the level of the road. This created the lovely garden area seen here where generations of choir members and church patrons would have their photos taken. (Courtesy Jean Garrity.)

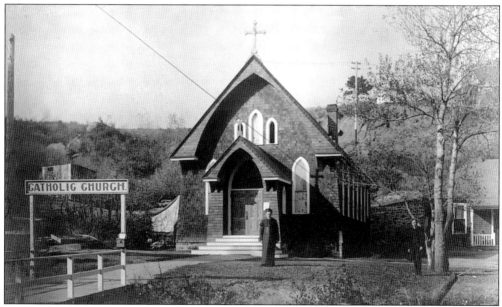

The Catholic Church was also well represented with this Shingle style wooden building, erected in 1889. The original sanctuary had been located on a residential street above Manitou Avenue, while this site was picturesquely sited in wooded Ruxton Canyon. The church was expertly restored after a major fire in the 1980s. (Courtesy Colorado Historical Society.)

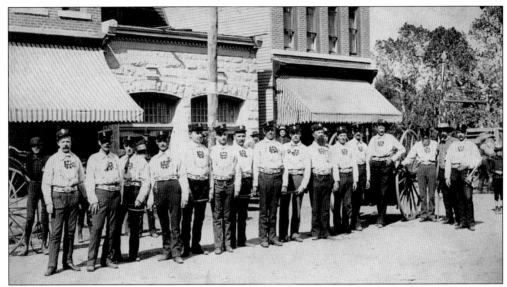

As with all Victorian wooden towns, the threat of fire was alarming. This encouraged large contributions to the local volunteer fire department, seen here in running formation with the hose cart. They are posing in front of the one-story stone station, wearing their special uniforms with William Bell's monogram embroidered on the front.

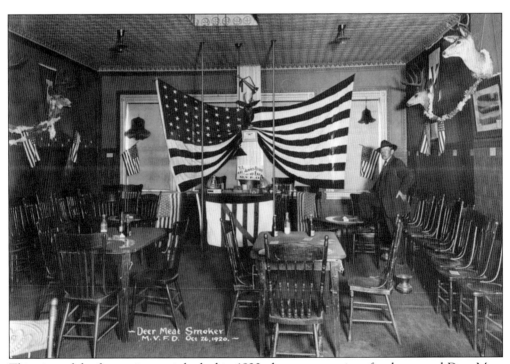

This view of the fire station, as it looked in 1920, shows preparations for the annual Deer Meat Smoker. Victims of previous celebrations hang on the walls and the ubiquitous cards and beer sit on the tables. The placard reading "We are always ready to eat—M.V.F.D." says it all. (Courtesy Manitou Springs Volunteer Fire Department.)

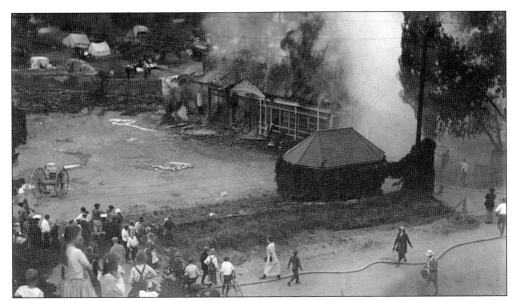

This 1907 fire tested the mettle of the Manitou Springs Volunteer Fire Department. Hiawatha Gardens was a private gambling club for gentlemen only, but plenty of ladies came to watch it burn. The rebuilt structure had a long history as a dancing pavilion and restaurant. (Courtesy Manitou Springs Volunteer Fire Department.)

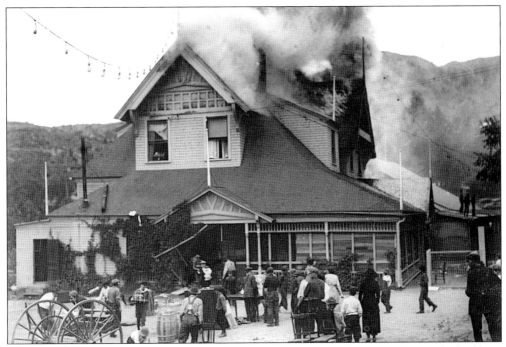

This earlier view of the same blaze shows the fire department hard at work to save the building. They were partially successful. It is to the credit of these volunteers that no large areas of Manitou Springs were ever lost to a conflagration and many lives were saved, even though the friction between a mortgage and a match was quite frequent in hard times. (Courtesy Manitou Springs Volunteer Fire Department.)

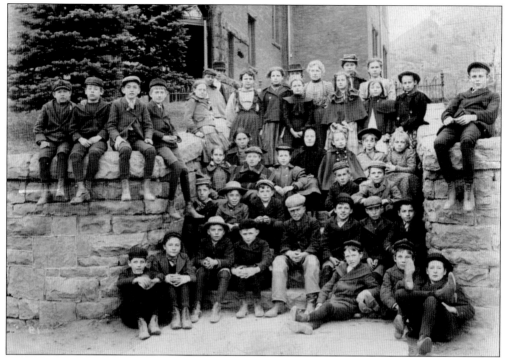

Considering the small local population, Manitou Springs' first schoolhouse built in late 1875 was quite an accomplishment. The white sandstone building with cupola was replaced in 1888 with the much larger red stone and brick structure seen here. (Courtesy Historic Manitou, Inc.)

Until 1900, Manitou Springs only offered a three-year course of study for the older students. Many children had to board with families in Colorado Springs to attend Palmer High School. This partially explains why the graduating class of 1896 was so small. (Courtesy Carol Warner Davis.)

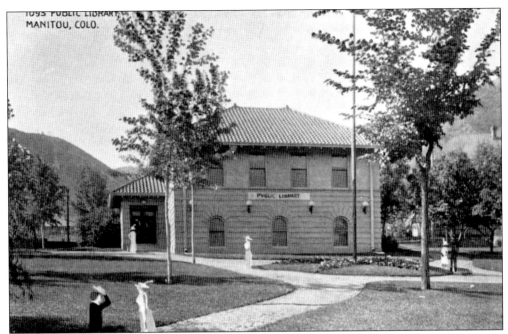

Until 1911 the local library consisted of a few thousand books, shuffled around between donated storefronts. The migration ended with the construction of this Italian Renaissance Carnegie Library on the former site of Dr. Davis' Drug Store. Dr. Henry M. Ogilbee was the irresistible force behind this effort and insisted that a large park be included to replace others being lost to development. (Courtesy Historic Manitou, Inc.)

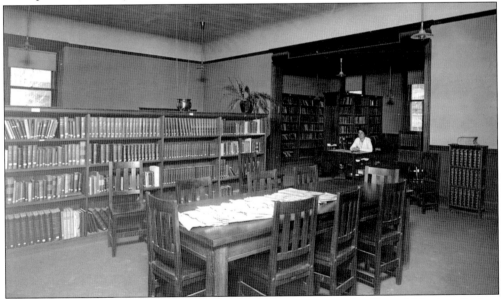

Due to the shortage of affordable space in the booming resort, the City of Manitou Springs decided to move their offices into the lower floor of the Library building and a door was inserted to facilitate customers. The Carnegie Foundation felt this was in violation of their rules, so the offices were moved and the library has changed little since then. (Courtesy Manitou Springs Public Library.)

Dr. H.M. Ogilbee was one of Manitou Springs' most trusted doctors. He served as town trustee and mayor, and had quite a flair for real estate. His greatest pleasures were his family and improving his adopted town. Many of the stone bridges, the old post office on Manitou Avenue, and the Carnegie Library owe their existence to this excellent citizen. (Courtesy Jean Garrity.)

Dr. Ogilbee came to Manitou Springs for his health, stayed at the Cliff House and became life-long friends with E.E. Nichols. For a few years he and his family lived above the office he had built on Cañon Avenue, seen here behind the very proper doctor. When a lot became available next to the Cliff House, the Ogilbees quickly decided where their permanent home would be located. (Courtesy Ed and Meg Nichols.)

116

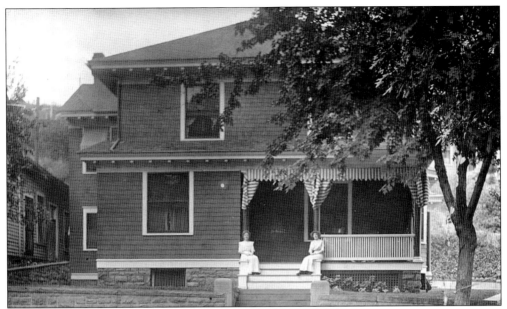

In 1900 the Ogilbee house was completed on the corner of Washington and Cañon Avenues. The classic American Four Square (four rooms up and down) suited the personality of the good doctor: no nonsense, practical, and yet endearing. Henry and his wife Gertrude raised three children here and the home has managed to stay in the family until the present day. (Courtesy Jean Garrity.)

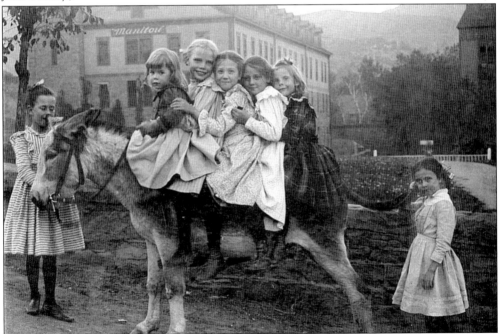

This charming vignette called "Rocky Mountain Telephone" shows two of the Ogilbee children. Mac sits at the head of the unfortunate animal, while sister Jean, in the dark dress, is at the tail. The eldest son Donald was probably too old to want to be in this kind of picture. The Manitou Bottling Plant stands in the background. (Courtesy Historic Manitou, Inc.)

Dr. Basil Creighton followed his brother Ed to Manitou Springs as yet another tubercular sufferer who stayed on. He was known as an intelligent, thoughtful man who would take care of any patient, no matter their ability to pay. After his brother passed away, the Creightons ran the old saloon as a pharmacy and soda fountain catering to such guests as Dwight and Mamie Eisenhower, long before they rose to prominence. (Courtesy Edwina Forde.)

Dr. Creighton delivered many a baby and was said to have never lost a child or mother. In an apartment in Manitou Springs, perhaps the one above Ed Creighton's saloon, Basil and his wife Maud pose with their own young son, Basil Jr. (Courtesy Deborah Harrison.)

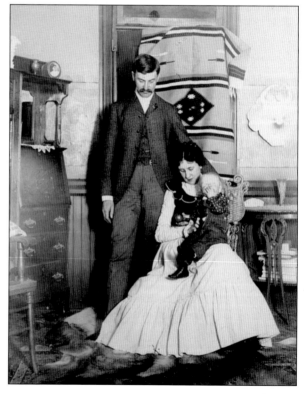

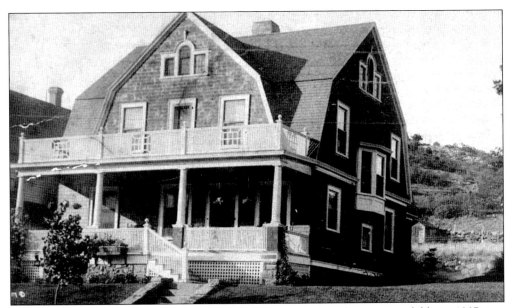

This Colonial Revival style residence on Washington Avenue became available in 1907, just when the Creighton family needed to expand into a larger home. Charles Barker had lived here previously, until the hotelier's death in 1905. Dr. Creighton also lived here until his passing in 1966 at the age of 102, the oldest licensed physician in the State of Colorado. (Courtesy Deborah Harrison.)

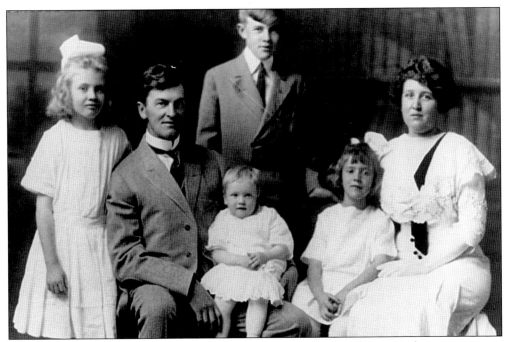

Dr. Creighton was a great believer in the medicinal qualities of the mineral springs, writing a treatise on them and owning a few at various times. He certainly managed to keep his own family healthy. From left to right, they are Alice Bernice, Dr. Basil with baby Edwina, Basil Jr., Mary Forest, and Maud. (Courtesy Edwina Forde.)

Artists were also well represented in Manitou Springs, most of whom sold their wares to tourists. However, this stylish building, known as the Craftwood Shops, housed workshops for an Arts and Crafts Association that sent their products to fashionable stores on the west coast. A retail store was also open on the grounds for more local consumption. (Courtesy Jean Garrity.)

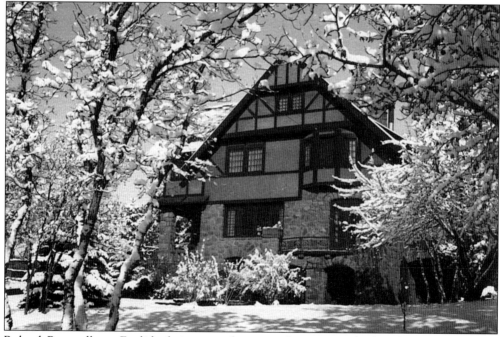

Roland Boutwell, an English designer, architect, and coppersmith, founded the Craftwood Association, which also built this structure, Onaledge, as housing for artists. It was later purchased by the owner of Rockledge, a nearby estate also designed by Boutwell. (Courtesy Jean Garrity.)

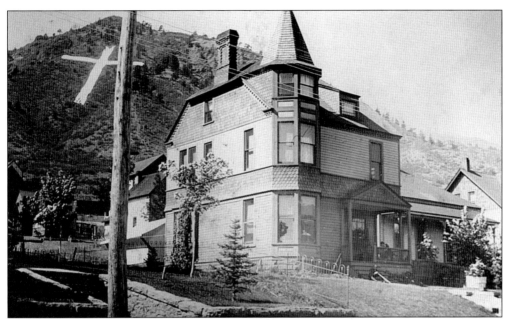

As Manitou Springs progressed into the 20th century, the elegant buildings started to look a little old-fashioned to the modern tourist. Health seekers began to diminish, while pleasure seekers increased. Conventions also became increasingly important in filling the many hotel rooms. This cross on Red Mountain was erected to honor the great conclave of the Knights Templar meeting in Denver in 1892, many of whom were to travel to Manitou Springs on an excursion.

The Knights returned to Denver in 1913, and the city of Manitou Springs felt obliged to outdo their last effort. Another, even bigger cross was draped across the mountainside and two arches were erected on Manitou Avenue, at Pawnee and Ruxton Avenues. These were later moved to the east and west boundaries of the city and used as advertising for the Cave of the Winds. (Courtesy Historic Manitou, Inc.)

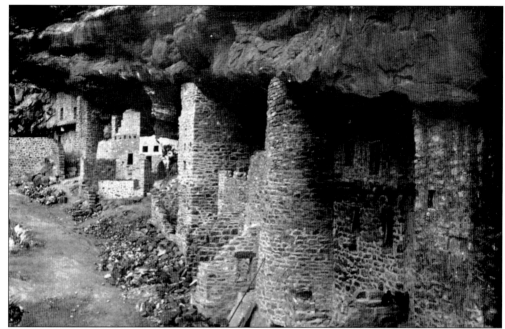

After the turn of the century, attractions began to outweigh natural wonders in the minds of vacationers. To satisfy this need, William Crosby, a Manitou Springs businessman, decided to buy and move portions of cliff dwellings from private property owners in the Mesa Verde area to a canyon adjacent to Manitou Springs. The motivation was greater public exposure for these ancient monuments, with a little profit added in. (Courtesy Historic Manitou, Inc.)

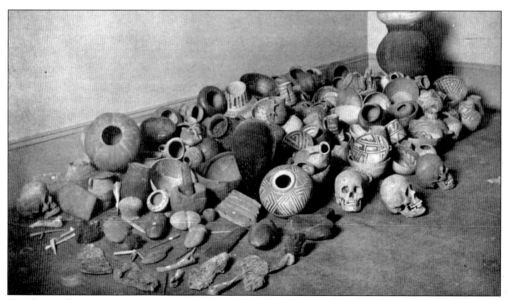

Crosby tried to counter any misgivings from the scientific community by hiring an archeologist to supervise the transfer. Great care was taken to label every stone, photograph them, and reconstruct them exactly in their new location. In the end, the debate led to the creation of Mesa Verde National Park in 1906. (Courtesy Historic Manitou, Inc.)

Images of Native Americans had always been used to promote Manitou Springs, though few were allowed to live there. During the early part of the 20th century, local entrepreneurs decided to import the real thing and brought many families off the reservations to entertain the tourists. This is a view of the Ute Chief Gusher at the western edge of Manitou Springs being advertised in Native style. (Courtesy Historic Manitou, Inc.)

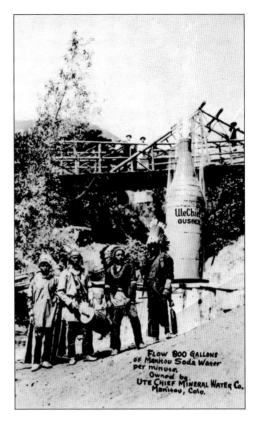

Chief Manitou, whose real name was Pedro Cajete, was a Santa Clara Indian who came to Manitou Springs every summer and managed to be included in an amazing number of tourist's photographs. He was always a very good sport about playing the stereotype "Indian Chief," though he used his earnings to help protect Native lands. (Courtesy Historic Manitou, Inc.)

The ultimate tourist attraction, the Mt. Manitou Incline, was originally built to haul water pipes for the Colorado Springs hydroelectric plant construction. Bought by a Mr. Brumbach in 1907, it quickly became de rigueur to have your picture taken at the upper station. Indulging in a little sightseeing with the tourists are locals Ida Nichols (second row from bottom), Donald Ogilbee (fourth row), and Jean Ogilbee (fifth row). (Courtesy Jean Garrity.)

Colorado's Greatest Scenic Attraction

Beautiful Mt. Manitou and Mt. Manitou Park

Mt. Manitou as Seen From Lower Station

Not only did the Mt. Manitou Incline provide some spectacular views on the way up, there were also campgrounds and picnic areas to enjoy once you made it to the top. This brochure shows the original lower station, which burned in 1914, and the third Iron Springs Hotel, formerly the casino across the street. (Courtesy Historic Manitou, Inc.)

Considering the success of the Mt. Manitou Incline, investors hatched a scheme to put another incline up Red Mountain, which had a better view of town. By 1912 the Red Mountain Incline was installed and running next to and over deep ravines on its way to the top, creating a ride so frightening that no one wanted to try it, guaranteeing a perfect safety record. (Courtesy Pikes Peak Library District.)

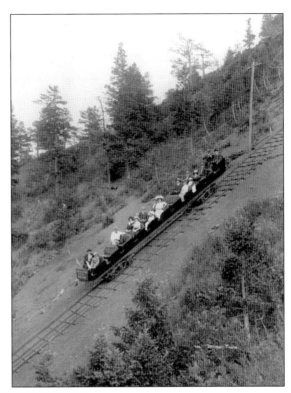

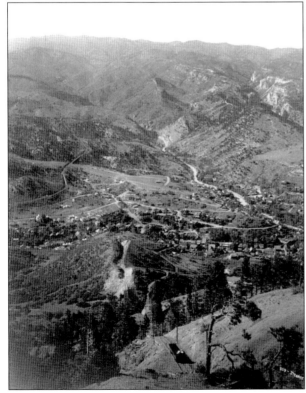

This view illustrates the dangerous looking vistas that closed the ride down by 1915. It started up once more around 1923 and again lasted only two years. During the construction of a power plant, they moved the body of Emma Crawford, who had been buried on the peak in 1891. There was no talk of curses at the time, but in hindsight, there should have been. (Courtesy Pikes Peak Library District.)

125

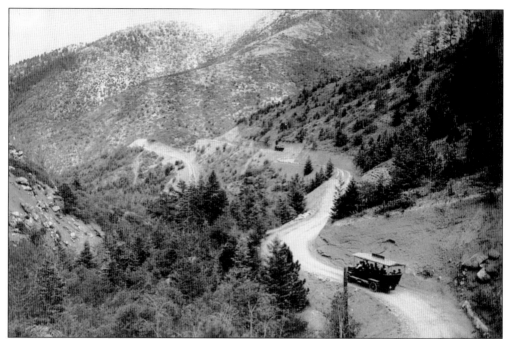

Crystal Park had been largely unexploited since John Hay owned it in the early 1880s. In 1909 work began on an impressive touring road to take advantage of the latest in transportation technology. Tourism would now be driven by the automobile up sinuous mountain highways like this one. (Courtesy Historic Manitou, Inc.)

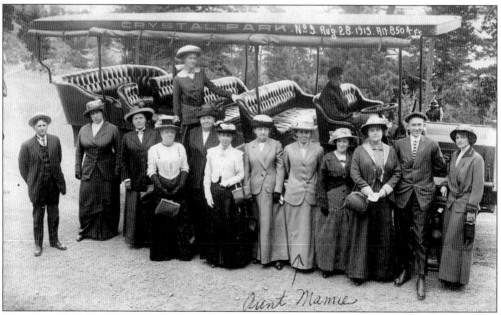

The Crystal Park Auto Touring Company owned twelve Packard touring cars like this one, complete with a friendly guide and a driver/mechanic. Mechanical breakdowns must have been a frequent occurrence, but no one would have complained very much considering the spectacular views. (Courtesy Historic Manitou, Inc.)

Automobiles were certainly the wave of the future, but Manitou Springs had roads from the past. The Cave of the Winds solved this problem by building a new scenic highway to their state of the art visitor's center above the original entrance, so visitors would no longer have to climb those old stairs. (Courtesy Historic Manitou, Inc.)

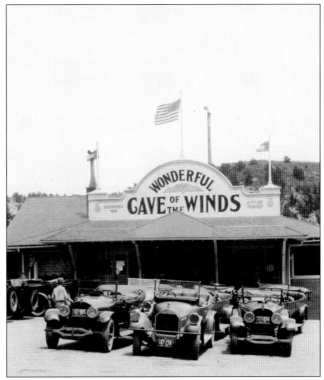

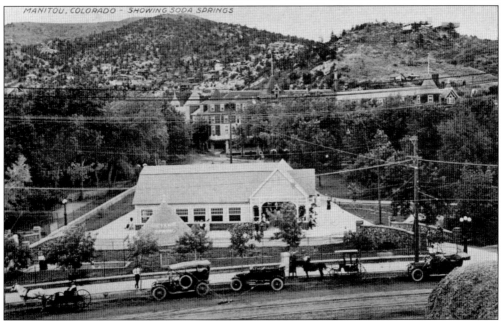

This photograph makes it clear how Manitou Springs had to change to stay attractive to potential tourists. The venerable Manitou Soda Spring Pavilion has a modern coat of stucco covering the Victorian decorative gables and the fancy touring cars are definitely outshining the old-fashioned horse and buggies. By 1920, the pavilion would be torn down for a modern spa facility. (Courtesy Historic Manitou, Inc.)

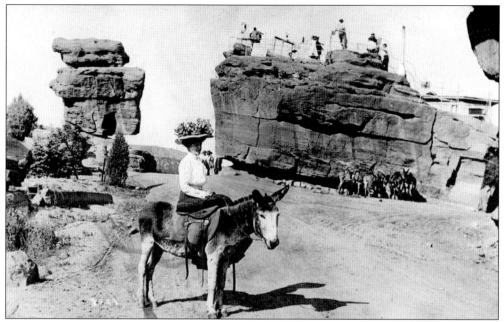

Early visitors to the area appreciated the clean, healthy atmosphere, the life-giving waters of the mineral springs, the numerous scenic attractions, and the excellent accommodations. But time marches on in Manitou Springs as it does everywhere else, and the nature of tourism changes. (Courtesy Historic Manitou, Inc.)

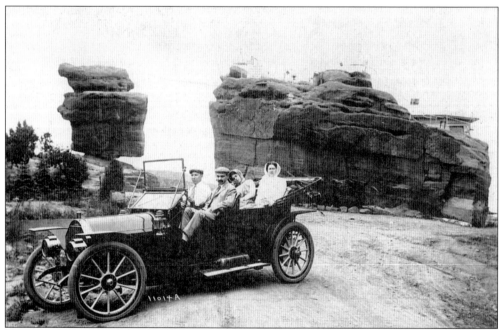

Now everything old is new again, and those outdated reasons for coming to the Pikes Peak region have resurfaced. As the car replaced the burro, so the hiker replaces the car. Ecotourism, alternative medicine, and historic preservation are bringing back those aspects of the past that will always be appreciated. (Courtesy Historic Manitou, Inc.)